IMAGES
of America

ALLEN PARK

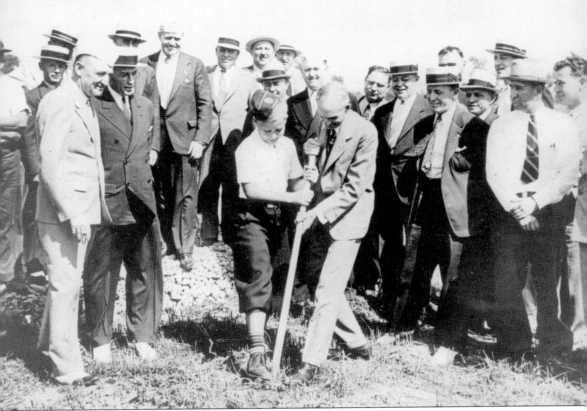

A gift of 39 acres of land from Henry and Clara Ford made possible the construction of one of the largest medical facilities in the United States for all men and women who served in the armed forces. July 27, 1937, was a special day when Henry broke the ground to start the building of the facility. The young man assisting Henry is Donald Aday.

On the cover: This picture was taken on June 20, 1939, at the dedication of the Veterans Administration hospital, which stood on the corner of Southfield and Outer Drive Roads. The long list of dignitaries includes members of the Ford family and Eleanor Roosevelt. The site immediately became one of pride for Allen Park and the areas surrounding. The massive structure of the building was a welcome-home sight for many Allen Parkers. (Courtesy of John D. Dingell Veterans Administration Medical Center, Allen Park Veterans Administration Hospital Archives.)

IMAGES
of America

ALLEN PARK

This is where your mom made history!

Sharon Broglin
for the Allen Park Historical Museum

ARCADIA
PUBLISHING

Published by Arcadia Publishing
Charleston SC, Chicago IL, Portsmouth NH, San Francisco CA

Printed in the United States of America

Library of Congress Catalog Card Number: 2007922154

For all general information contact Arcadia Publishing at:
Telephone 843-853-2070
Fax 843-853-0044
E-mail sales@arcadiapublishing.com
For customer service and orders:
Toll-Free 1-888-313-2665

Visit us on the Internet at www.arcadiapublishing.com

Allen Park celebrates 50 years as a city in 2007.
This book is dedicated to those who built this city. Your dreams,
hard work, and perseverance have given Allen Park a place on the map.

CONTENTS

Acknowledgments 6

Introduction 7

1. Township, Village, City: Pioneers, Farms, and Homes 9

2. Guiding Lights: Churches, Schools, and Organizations 31

3. A Day in Town: Stores, Businesses, and Streets 55

4. A New Life: The Immigrant Experience 79

5. Community Spirit: City Planners, Protectors, and Places 87

6. Memories: Events, Sites, and Celebrities 111

7. Honored: The Veterans Administration Medical Center 123

ACKNOWLEDGMENTS

To fellow historical commissioners Barbara Ferencz, Cynthia Robertson, Bill O'Donnell, Betty Backus Nixdorf, Linda Shelton Milne, and Dave Doss, you never once questioned the possibility of this book. Betty, a descendent of the Backhaus family, was always prepared with pictures and information. Linda, a dedicated assistant and a descendent of the Beaker and Lafferty families, gave pictures and knowledge, along with many long hours and late nights of organizing and correcting. Cynthia always made sure all the other projects continued during this historical endeavor along with Barbara and Bill. Thank you for the use of the information from the museum files.

Through the years, many individuals have donated photographs and information to the Allen Park Historical Museum, preserving our past. Pat Hall, secretary to the superintendent of Allen Park public schools, saved historical school records from going to the dumpster. Lynn Ketelhut donated funds used to restore old museum photographs. Photographer Vincent Martini always went willingly to take pictures we needed at his own expense. Dan Scott, founder of Focusallenpark.com, went to great heights to photograph certain pictures. Terry Fadina's photograph from Timeless Images was a needed contribution to the book. The scanning expertise of Mike Hackett and Joe Hirsch at the Whipple Printing Company got the book off the ground.

Historians Orrin Wright, Frederick N. Schwass, Ken Lieber Sr., and Elmer Theeck were the keepers of our early history. Barrett Lafferty captured local history with his camera. In 2001, the mayor, council, and Kevin Welsh bought the 1888 home to store the history. The mayor and council of today are our continuing supporters, along with the townspeople. Thank you for your contribution to the history of this town. Thank you Karen Tubolino of the John D. Dingell Veterans Administration Medical Center for picture releases. A big thank-you to Ashley Koebel of the Burton Historical Collection for help in obtaining the only known picture of Lewis Allen. Special thanks to Gale Crete for many reasons. Thank you also to Anna Wilson of Arcadia Publishing for working with me through these past months.

To my family, Randy, who said it could be done, Alan, who spent many late hours on the computer with me, Aaron, who called every day to offer help, Amy, Benjamin, Zaruhi, and Ando, who gave encouragement, along with my relatives and friends, thank you and I love you. To my parents (Nash and Fran Kehetian) and grandparents (Kaspar and Alice Kehetian), thank you for always bringing my brother, Nash; sister, Darlene; and me to this town as children. I wish all of you were here to share this book of history.

INTRODUCTION

Imagine the events in this area of over one and a half million years ago. There were huge glaciers of ice that slowly moved this way from the north, traveling to what is now the Ohio River. The glaciers covered this land for thousands of years. Then for thousands of years more, they slowly moved north again, carving the streams, creeks, and lakes that gave Michigan the nickname "the Water Wonderland."

Thousands of years after that, the first man, the Native American, arrived in this area. Members of the Potawatomi, Chippewa, and Ottawa tribes, who were related and Huron tribes, paddled up and down the Ecorse River, fishing, trapping, and hunting along its shores. The Detroit River has an opening to the Ecorse Creek in Wyandotte that meanders through areas in what was called Ecorse Township. Soon the white man arrived in Detroit to trap the beaver that had already become extinct in Poland due to the fashion craze in Europe of a beaver hat. The French and English rushed to occupy the land that they had heard was filled with this animal. In 1701, Antoine de la Mothe Cadillac, a Frenchman, was the first to found the site that he named Detroit. Historians will say that Detroit was founded because of a beaver hat.

The first person to have extensive landholdings in what is now Allen Park was Pierre St. Cosme. St. Cosme, a Frenchman, befriended the Native Americans and received over 4,000 acres of land from them out of "love and devotion." He is responsible for bringing the settlers into Ecorse Township, which is known as the Downriver area today. In the early 1800s, the French pioneers settled on his land. The French would leave a lasting impression on this area and the entire area known as Ecorse Township.

Another landowner, Lewis Allen, had 270 acres of land that stretched from the Rouge River to the area where Thunderbowl Lanes and Arena stands today. Allen was an attorney from Detroit, but he never practiced law. Instead he lumbered his land and established a sawmill on the bank of the Rouge River. As more trees were felled in this part of Ecorse Township, the land became more suitable for farming. The 19th century neared its close, and agriculture became the principal industry in this area known as Allen Park. Closer to the Detroit River, the towns of Ecorse, River Rouge, Wyandotte, and Trenton were the shipping, shipbuilding, fishing, and industrial centers of Ecorse Township.

The available land attracted the German farmers. The French for the most part had left this area for land closer to water. Many of the French pioneers went to live in the town of Monroe, close to the Raisin River. German families became influential in the development of this town, and German names still seen today are a reminder of their contributions. It is impossible to talk about just one area of Ecorse Township without referring to other cities and areas. Many pioneer families moved to land in towns that bordered one another, extending history into those areas.

The farming days were prosperous, but soon life in the Detroit area was changed considerably by a young man named Henry Ford who founded the Ford Motor Company in 1903. In 1908, the Model T was introduced and was about to be responsible for putting "the world on wheels." In 1913, Ford developed the assembly line and offered a wage of $5 a day. The line of job seekers was a sight to see, many of them farmers from Allen Park. By 1927, over 15 million Model Ts had been sold, making it the largest-selling automobile of all time. The farmers in Allen Park and surrounding villages dreamed of an easier life working for Ford. The farmland was sold to developers, and subdivisions of neat, new homes were built. The years of major home building were the 1920s, 1940s, and 1950s, and by the late 1960s, most of Allen Park's land was developed with subdivisions.

Allen Park attracted many new residents from the crowded city. The new arrivals to this town were mainly from the southwest side of Detroit. For the first time joining the German pioneer families, new immigrants came to buy the attractive homes in new subdivisions. New churches, schools, shopping areas, and restaurants were built. Children no longer skated or swam in ponds on farms. The residents, including youth and seniors, were provided many special programs provided by the city.

The population grew fast. By the late 1950s, people could shop here and be able to buy just about anything they would need. Every major religion had a place of worship in the 40 churches that once existed. The organizations that supported the many causes in the town were at an all-time high. The baby boom created the need for organizations for the youth and parents of the youth. The military men and women were home from most of the conflicts, and groups were formed for them. The city of Allen Park was a well-rounded community that attracted many new residents.

The opportunities for all ages would send many Allen Parkers out into the business, sports, and entertainment world. Many of their names would eventually be in the limelight. Those success stories have brought great pride back to their hometown. Events and happenings through the years would create special places of interest in the city, attracting many visitors. So many of the people, places, and events have put Allen Park on the map.

Today the city moves on with continuous changes. The veterans' hospital that no longer exists has been replaced with a beautiful new shopping center. A memorial to the hospital stands on the corner of the shopping center.

One

TOWNSHIP, VILLAGE, CITY
PIONEERS, FARMS, AND HOMES

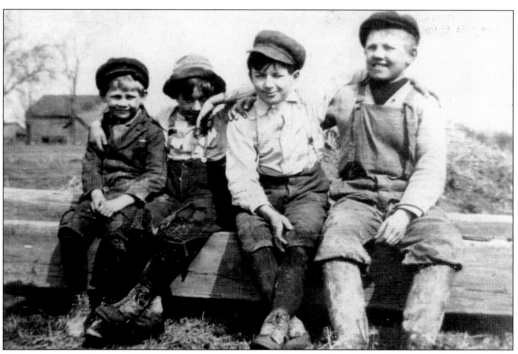

This picture, taken in 1910, hangs at the checkout lanes in the Meijer Store on Fort Street in Southgate. When the headquarters of the company approached the museum for scenes from Downriver, this was one that it chose to represent Allen Park. The representative felt the group of boys showed the spirit and innocence that existed in youth years ago. The photograph is a favorite of both young and old when they visit the museum. It was most likely taken on the Champagne farm. The Champagne family owned land in the mid-1800s. Pictured from left to right are Gustav Hinzman, Joseph Champagne, Frank Champagne, and Frederick Hinzman. The Hinzman farm was next to the Champagne farm.

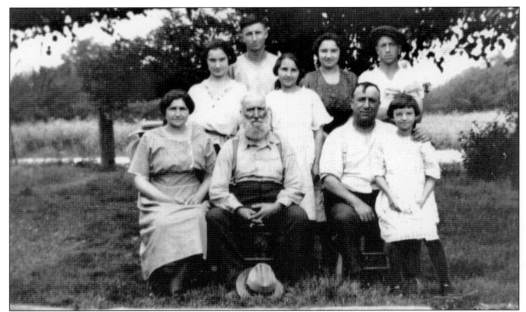

In 1918, nine members of the Champagne family gathered for this photograph. The earliest known settlers in this area were the French, although not in as great numbers as in neighboring cities such as Lincoln Park, Ecorse, and River Rouge. As the population in Detroit increased, the French settlers spread to areas north and south of the bustling town. Frank Champagne, seated on the right, became one of the first village council members when the community was incorporated in 1927.

This view of the Hubert Champagne farm was taken in 1908. The curving dirt road later became the intersection of Vine and Englewood Streets. A member of one of Allen Park's pioneer families, Elmer Theeck remembered that this picture was taken from the loft of the August Boelter barn. On July 1, 1776, French pioneer Pierre St. Cosme was given over 4,000 acres of land by the chiefs of the Potawatomi tribe. The land stretched from the Detroit River to the area where Thunderbowl Lanes and Arena is located today.

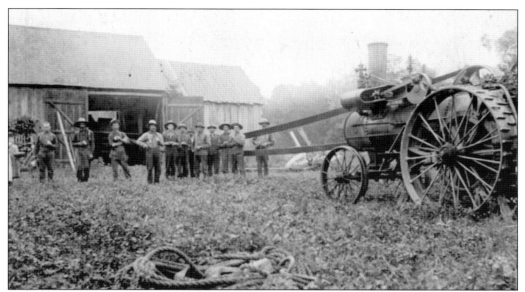

In 1910, the threshing crew came to harvest the wheat on the Hubert Champagne farm. The lasting influence of the French in the history of the Downriver communities was great and can still be seen today in such names of families, streets, and schools. The names that are remembered in the area include Champagne, Labadie, Salliotte, LeBlanc, Cicotte, Pepper, Drouillard, Bondie, and LeDuc, to name a few. As the land was cleared in the mid-1800s, the German farmers would come to live in this area.

This picture of January 13, 1918, shows farm owners Hazen Finner, Carl Theeck, Frank Theeck, Gustaze Hinzmann, Frank Champagne Jr., William Freeze, Frank Champagne Sr., Fred Hinzmann, and Joseph Champagne working on an unidentified farm. Community efforts such as this were common. Old-timers remember when the Champagne family flooded areas during winter for ice-skating and sledding. The family owned one of the few roads that could be traveled to other farms, known today as Champaign Road. The family name was also given to Champaign Park, one of the largest in Allen Park.

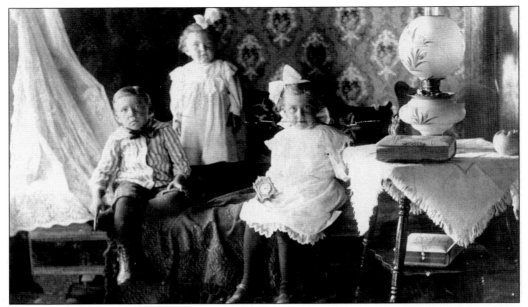

This is a rare picture of the inside of a farmhouse in the town taken at the beginning of the 20th century. Most pictures taken in rural areas at this time were taken with the family and pets standing outside their homes. The picture is of the Kolb children in their house, which was located on the corner of what is now Kolb and Ecorse Roads. It seems as though it might have been a special occasion. Note that the child on the right is holding a clock that reads 4:15.

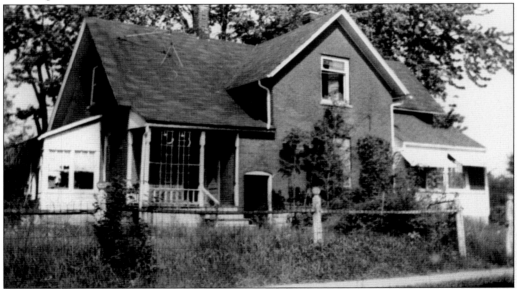

The home of Frank Kolb, located on the corners of Kolb and Ecorse Roads, stands empty and shows signs of decay. The home was demolished in the 1960s, and a real estate office stands in its place. The Frank Theeck farm stood on the other side of Ecorse Road. Many Allen Parkers remember taking their children to the last farm in town to see the ducks, geese, and chickens. When Theeck died, farming officially ended in Allen Park. Today an automotive parts store stands in the farm's place.

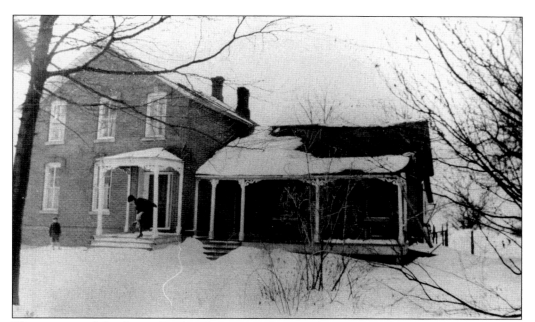

This picture of the Lester Boelter farm was taken in about 1910. The home was located at Champaign Road and Vine Street. Boelter served on the first village council as treasurer. South Junior High School, known today as Allen Park Middle School, stands in this area.

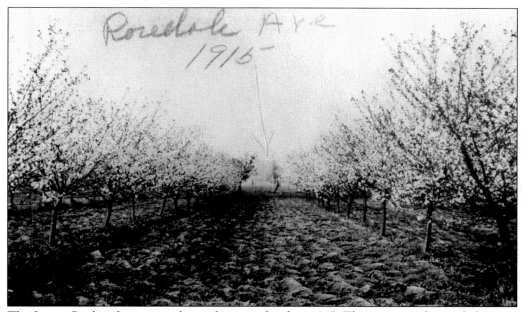

The Lester Boelter farm was a large cherry orchard in 1915. This scene is the road that was cleared to drive through the farm. Today it is known as Rosedale Avenue and is lined with homes. There were not many roads at this time, and farmers would allow neighbors to use the roads that ran through their farmland to get from one farm to the other. The Champagne farm was across the road.

This scene was taken in 1908 from the loft of the Lester Boelter barn looking toward what is now Allen Road. The haystacks in the distance indicate that summer was coming to an end. The farms in Allen Park were market farms. Typical crops grown here were wheat, oats, hay, corn, and other produce. The farmers also raised hogs, sheep, and poultry.

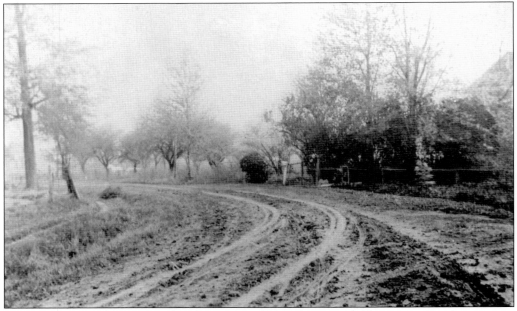

This winding, muddy road, today the corner of Vine Street and Champaign Road, is seen in 1910. The Boelter cherry orchards are in the background, and the barn is on the right. The Boelter farm was a 40-acre farm bordering the John Mackie, P. Odette, and P. Bondie farms.

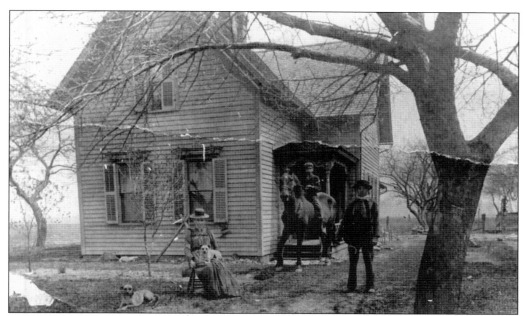

This picture of the Alex Durand home was taken in approximately 1895. The home was relatively new. Pictured are Emma Durand, Charles Guidot (on the horse), and Edward Koch. The farm was located on Pelham Road near Van Born Road. The Fred Koch and William Koch farms were down the road from the Durand farm.

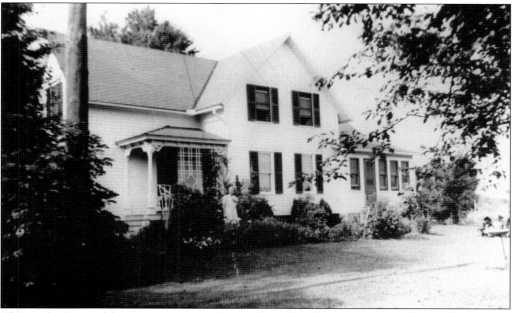

This is the Durand home, again located on Pelham Road near Van Born Road. This picture dates from around 1915. Notice the house is painted and this time the picture is taken from the side. There is a pole in the yard, but it is not known if it is a telephone or electric pole. Records are not clear as to when the utilities were brought to the village.

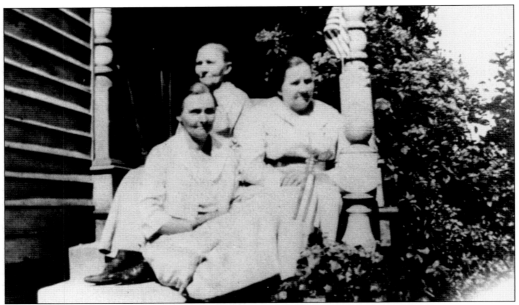

The women in this picture are, from left to right, Emma Durand, Kristina Krantz (who is Emma's mother), and Nell Rocklin. The picture of the three women was taken in a time period close to 1920 on the porch of the Durand home. The American flags on the porch suggest patriotism to the country during World War I or maybe decorations for the Fourth of July.

In the mid-1930s, the Durand family took this picture from the back side of the house on Pelham Road. The progress of the house and the family is shown in these pictures from the files of the Allen Park Historical Museum. It is rare to have the history of a home in pictures that covers the life of a family for almost 50 years. Henry Ford's $5 day and the Depression were about to be responsible for changing Allen Park's farming history forever.

This picture is of George Durand, the son of Alex Durand. George's daughter Valley Durand Becker was instrumental in giving the Allen Park Historical Museum valuable historical information on the schools and city. Becker also donated to the museum township maps from this and surrounding areas.

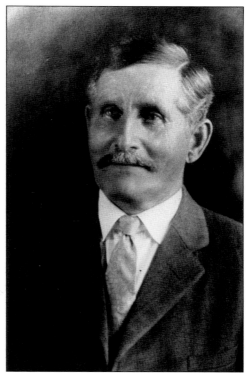

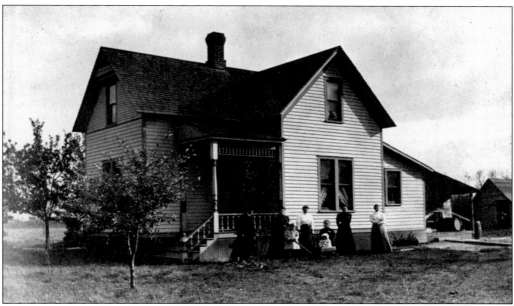

In 1910, the family of Herman and Ida Becker gathered outside for this picture. The home stood at the corner of St. Cosme Line Road and what is now Rosedale Avenue. St. Cosme was one of the three names for what Southfield Road is called today. A descendent of the Becker family recalls that the home was sold to developers and soon after that the Depression hit and the developer lost the home. The Becker family regained the home.

In 1918, this picture was taken of George Schafer driving his Reo automobile on a dirt road. The intersection is known today as Goddard and Allen Roads. George was the son of Charles Schafer. In 1957, when Allen Park incorporated as a city, he became one of the first councilmen.

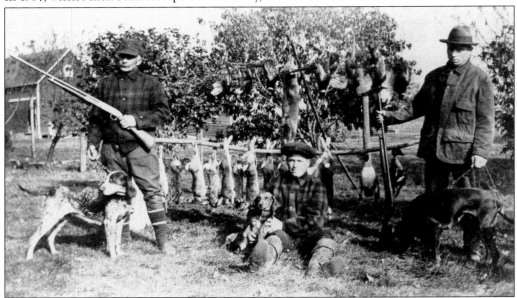

In the fall of 1924, Charles Schafer (left), George Schafer (center), and Frank Schafer went small-game hunting on their property in the village of Allen Park. According to records from 1925, members of the Schafer family still lived here, but many also owned farms in what is now Southgate. The large family eventually moved to different areas, and its contributions prompted the names of roads and schools in its honor. Historical records show variations in the spelling of the Schafer name.

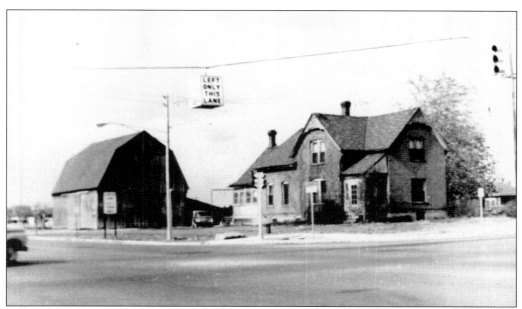

Townspeople still remember when the cows were being taken to and from the pasture. Many times the cows would get to the middle of the road and lay down, causing traffic to stop for hours. Detroiters remember driving to the farm to get eggs, apples, corn, and many other items. Soon after the farm was demolished, a McDonald's restaurant was built in its place on Allen Road at the corner of Goddard Road.

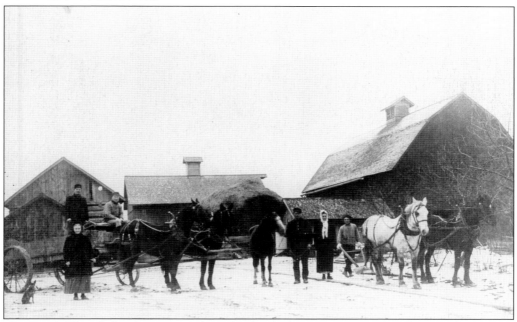

The Frank Theeck family is pictured on the family farm in 1901. In the photograph from left to right are Caroline Theeck, Pete Theeck, Charles Theeck, Bill Lehiman, Mary Lehiman, and Frank Theeck. The farm was located between what is now Champaign and Moore Roads. The family name spelling and the spelling of the street and park would soon be different.

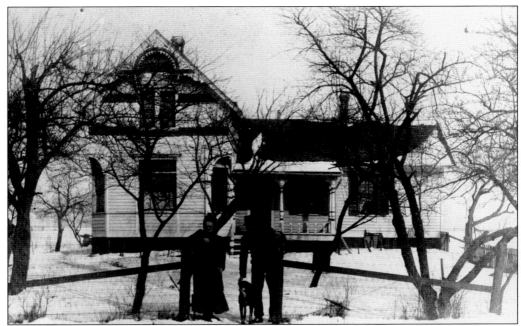

This picture of Charles (Karl) Theeck and his wife, Caroline, was taken in front of their home in 1901. Records from 1925 show five Theeck family farms in Allen Park. It was big news in town when one of the Theeck barns burned down. Many did not realize that the barn-burning was part of a fire drill. The Theeck farm on Ecorse Road is still remembered by residents today for keeping poultry until the 1980s.

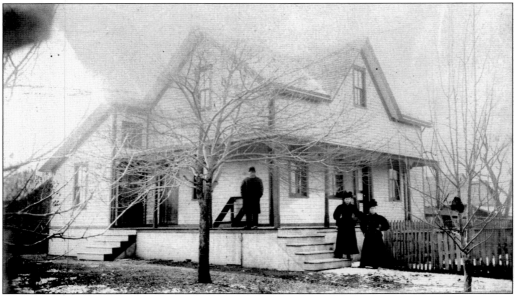

The home of Louis Weigert is pictured in the late 1890s. Standing in front of the home on St. Cosme Line Road, known today as Southfield Road, from left to right are Louis, Ida, and Louise Weigert. Mary Mueller Wendt, one of the Lapham one-room schoolhouse teachers, boarded with the Weigert family.

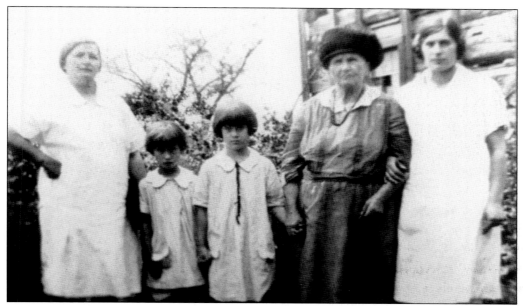

Frederich Wilhelmine Rinne (known as William) was born in Germany in 1848. He came to Ecorse Township in 1865. His log cabin stood on 15 acres of land close to Champaign Road. Shown in the picture from left to right are Luella Otter Hoffman, Augusta Krantz Rinne, Dorothy Otter, Delphine Otter, and Minnie Otter. The log cabin was moved to Huron Township, where Rinne resumed farming. Rinne Road was named after the family.

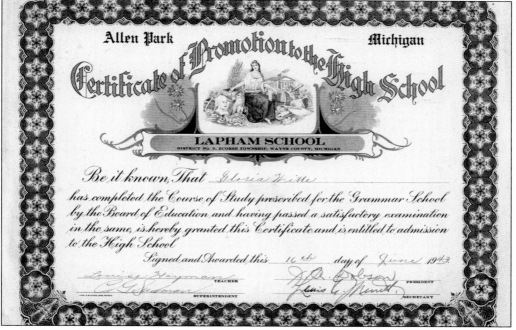

A certificate of promotion to the high school was awarded to Gloria Witte in June 1943. The first superintendent of Allen Park schools, Chester Sudman, signed the document. During this time period, the Lapham School on Allen Road was used for all grades.

This picture of Betty Beaker Shelton was taken on the family farm on Goddard Road in 1949. The water filtration plant stands near this spot today. Shelton's grandmother was Mary Lafferty. Lafferty's brother was the father of city controller Barrett Lafferty. This view of fire hydrants and sidewalks on land abandoned by developers during the Depression was a common site for many years. People driving through town in the 1950s and 1960s would joke about Allen Park, the town with the sidewalks that went nowhere.

In 1949, this picture of Linda Shelton Milne was taken on her grandfather Arthur E. Beaker's farm located on Goddard Road. Across the road was her German-born great-grandfather's farm. Many German farmers came from the same villages in Germany. Mecklenburg was one of those cities.

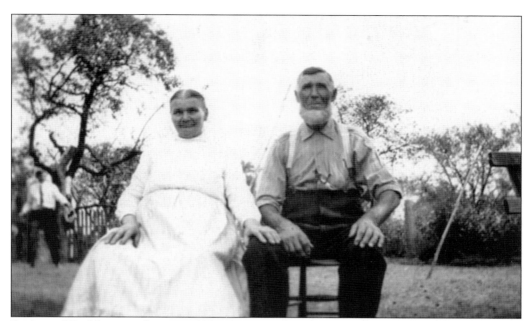

Ferdinand Backhaus was born in 1835 in Prussia, where he married Henrietta Wischow in 1863. They came to America from Hamburg, Germany. In 1872, the Backhaus family moved from Detroit to a 40-acre farm in Ecorse Township. The first home, a log cabin, was replaced by a brick home in which Ferdinand and Henrietta raised eight children.

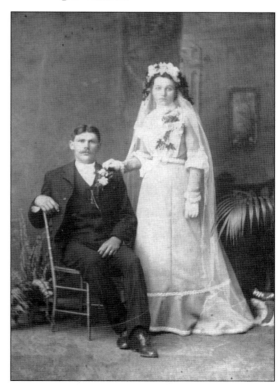

In 1902, Louis Backus, son of Ferdinand and Henrietta, married Emma Lange of Lincoln Park. Backhaus, Lange, and Lapham were some of the names in the wedding party. They had two sons. Louis was a charter member of the first village council and served from 1927 to 1937. Notice the spelling of this branch of the family name has changed.

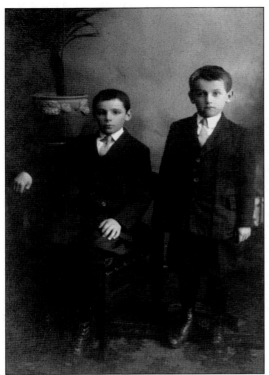

This picture was taken in about 1912. The boys are Arthur and Harry Backus. Notice the spelling of the last name changes. Soon after this picture was taken, Harry died from the plague. Arthur attended the Lapham one-room schoolhouse until fifth grade. The home they lived in was on the 40-acre farm of their grandfather Ferdinand Backhaus. It was moved to Jonas Street in Lincoln Park, where it still stands today.

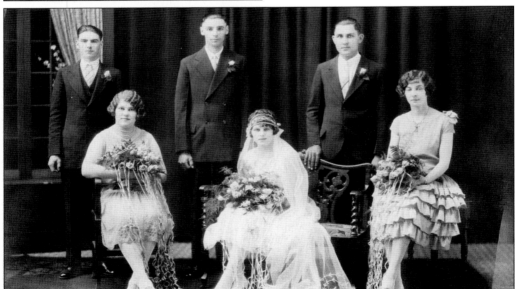

Arthur Backus married Dora Porath from Southgate on June 1, 1927, at Trinity Lutheran Church in Wyandotte. Pictured are, from left to right, Martin Porath, Myrtle Porath, Arthur Backus, Dora Porath, Clarence Ziesmer, and Elizabeth Ragal. The Backus family children, Leonard Backus and Betty Backus Nixdorf, were born in their home and attended Lincoln Park High School. There were no hospitals in Allen Park at the time. Nixdorf presently works with the Allen Park Historical Museum, the former home of her great-grandfather.

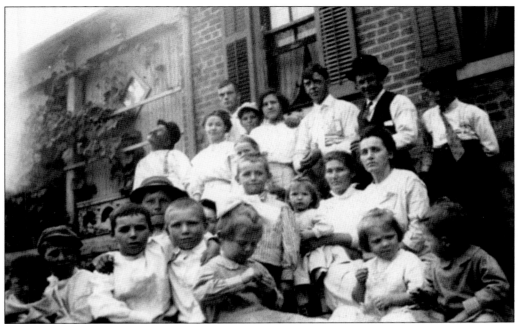

The Backus family gathered at the old farmhouse on Englewood Street and Park Avenue on August 3, 1913, celebrating the 70th birthday of Henrietta Backhaus. The house was built of red brick from a Detroit brickyard. Today the house is painted gray. The Backhaus family has at least four variations in the spelling of their last name.

This view of the Backhaus house was taken in 1951. Park Avenue has been paved, but Englewood Street is still a dirt road. The houses in the background indicate that subdivisions were already being built in that area. In 1888, the farm had 40 acres. Soon the farm would no longer belong to the Backhaus family.

On August 28, 2001, the mayor and council purchased the former Backhaus home to be used as the Allen Park Historical Museum. Elegant on the corner lot, the 1888 structure is a reminder of the town's farming past. The members of the Allen Park Historical Commission worked diligently with organizations, corporations, individuals, and citizens who volunteered time and money to help restore the home.

Janine Eckmeter Hall (left) and her sister Joyce Eckmeter Wagoner are in the backyard of the family home of James and June Eckmeter on Champaign Road near Park Avenue. The year is 1952, and barns are still standing in between the subdivisions that were being developed. Their father, James, was a well-known certified public accountant for many years.

The Schultz, Finner, and Witte families were related, and their farms were close to one other. This picture shows a Witte boy on his farm on Grey Street. After the land was developed, people found green sprouts coming up through the grass in the early spring and were surprised to learn that it was asparagus growing back year after year from the many fields that had been planted with it when the land was farmed. Gloria Witte did her homework by the light of an oil lamp in the early 1920s because there was no electricity in town. The lamp has been donated to the historical museum.

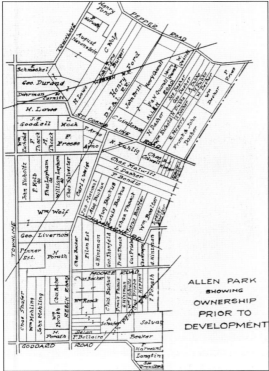

This map shows the names of the last owners of the farms before they were sold to developers in the late 1920s. Most of the pioneer names that were common at the beginning of the 20th century still remained on the map. Multiple generations stayed, and today there are still descendents living in the city that their pioneer families settled over 150 years ago.

27

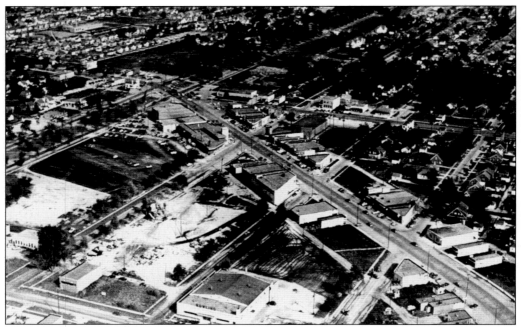

This aerial view of Allen Park in the early 1950s shows the farms being replaced by housing. Roosevelt Bowling Lanes can be seen in the foreground. In the center of the photograph, one can see the Allen Park Theater, Albert's Supermarket, and Maury's Triangle Restaurant.

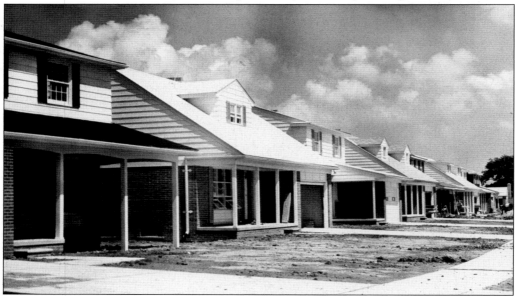

In 1959, tidy rows of new homes popped up all over the city of Allen Park. Most Allen Park homes were built during this time. During the 1930s, developers offered farmers poor prices for their land. The developers put in fire hydrants, sidewalks, and driveways before building homes. During the Depression, many developers lost farms they had purchased. For many years, visitors passing through town wondered why so many roads ended nowhere and why so many fire hydrants had no homes to serve.

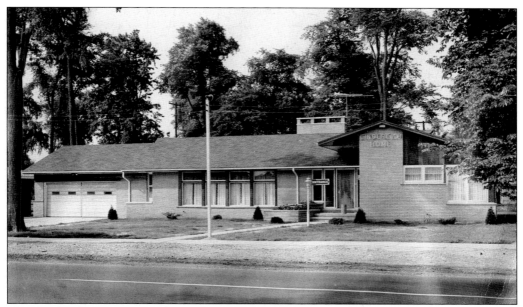

The Cinderella Homes were located on Southfield Road south of Pinecrest Street. They were some of the most modern homes in Allen Park during the 1950s. The homes were raffled by a group of Catholic churches to make money to build new churches. St. Francis Cabrini was one of the churches built with the monies. This home was built to include many new features, one of which was a solarium.

Elmer Benny bought the Cinderella solarium home from the original owner who put the house up for sale one week after he had won the prize. Elmer and his mother Velma Banyai, who lived with him, came from Hungary. Elmer changed the spelling of his last name from Banyai to Benny.

After World War II, the desire for new housing increased as troops returned home to marry. Allen Park was a much sought after place to live. Advertisements in the *Detroit Times* for homes in Allen Park were common. The Princeton Estates was one of the most desired subdivisions in the 1960s. The subdivision is on Outer Drive Road and still attracts buyers.

The history books often described the Ecorse Township area that became Allen Park as a "lazy, farming hamlet." This picture of the Schafer farm is a reminder of those days. Henry Ford's $5 workday and the assembly line drew people from all over to this area. With the end of World War II and with women working outside the home, many changes took place. New homes replaced farms, and paved highways replaced country lanes. By the 1950s, few farmhouses remained. The right to farm was abrogated in Allen Park in the 1980s.

Two

GUIDING LIGHTS
CHURCHES, SCHOOLS, AND ORGANIZATIONS

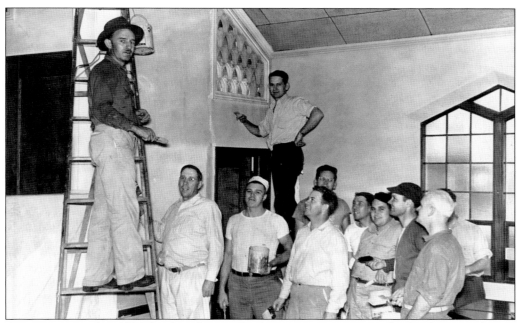

A mission started in 1926 developed into a Presbyterian congregation, the first known religious group in Allen Park. The Allen Park Presbyterian Church located on Park Avenue was founded in 1932. Many early parishioners met in schools until churches were built. In 1953, the Trinity United Methodist Church held its first service in a new church on Allen and Reeck Roads. In 1947, St. Frances Cabrini began holding services in the public schools until a church was built in the late 1950s. St. Luke's Episcopal Church located on the corner of Wick and Niver Roads opened its doors in 1952. It was a common sight to see parishioners, such as these unidentified Presbyterian church congregants, tending to their churches.

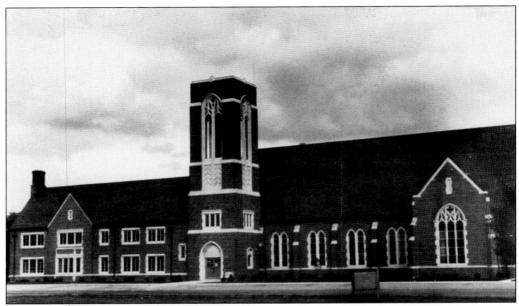

The Allen Park United Presbyterian Church was completed in 1940. The church contributed in many ways to the city. Many remember the pageants that were produced at Christmas with live animals. Years later, it was renamed the Allen Park United Presbyterian Church.

This picture is of Camp Wakanda, owned by Boy Scout Troop 1, the first Scout troop in Downriver. Sponsored by the Allen Park United Presbyterian Church, the troop is now known as Boy Scout Troop 1051. The camp is located in Johannesburg, north of Grayling. Prominent church members bought the camp for the Scouts. Today the Allen Park United Presbyterian Church operates the camp. Scouts and many other church groups use the camp. Many young people of different faiths from Allen Park have fond memories of attending youth activities at Camp Wakanda.

Mayor Frank J. Lada and Rev. Fred Van Halla shake hands at St. Matthew Lutheran Church. The large German population of the 1800s prompted the founding of several Lutheran churches. St. Matthew was on Allen Road, not far from Ecorse Road. Early settlers traveled by horse and buggy to Lutheran churches in Taylor, Dearborn, and Detroit. Elmer Theeck remembered his family taking a route that took almost half the day to get to a baptism in Taylor when the roads were washed out from the rain.

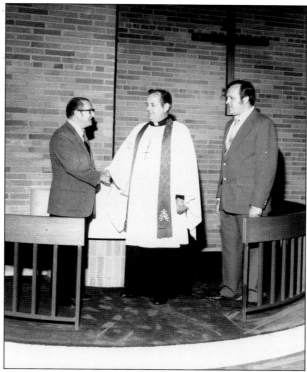

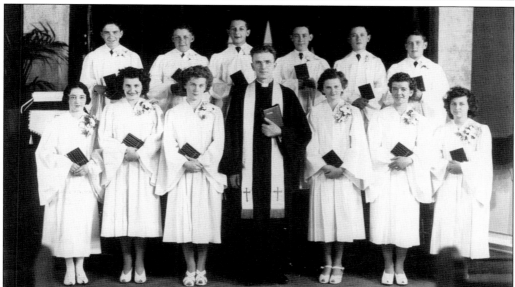

This is the confirmation class of Angelica Lutheran Church in the late 1930s. The church is located on Park Avenue near Englewood Street. Many of the German pioneer families were responsible for the building of this church. The second-oldest church in Allen Park is Mount Hope Lutheran, established in 1930. The first building was located in the old Dasher School on the corners of Allen Road and Outer Drive Road. In the 1950s, Mount Hope moved to Southfield Road, its present location.

Mary Mueller Wendt (Mary Miller) taught in the one-room Lapham School around 1890. She made less than $40 a month and boarded with families. Sketchy records show Edith Whipple and a Miss Lanser were teachers in the Lapham School from 1900 to about 1910. Winifred Powers, who married Joseph Goebel, son of Catherine Kolb, recalled qualifying for her teaching license at age 16 after completing eight years of grammar school. Catherine's sister, Stella, was her assistant in the one-room school. Powers also taught in Lincoln Park.

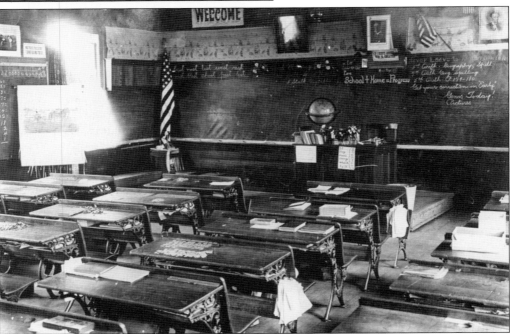

This picture of the interior of the first Lapham one-room schoolhouse was taken about 1915. The Lapham family donated the land on which the school was built near the corner of Ecorse and Allen Roads. The Lapham farmhouse stood on the corner of Osage Street and Ecorse Road.

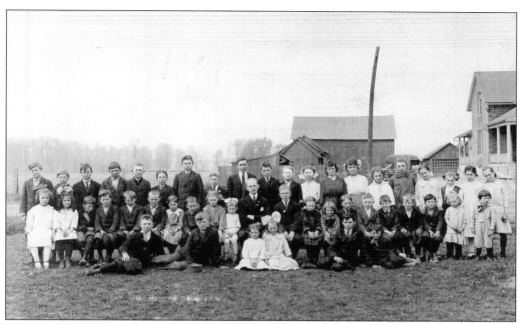

This picture of the Lapham class of 1915–1916 was taken on the Herman Arno farm. Herman Arno owned the farm across the road from the school and his brother, Fred Arno, owned the farm next to him. The farms faced Roosevelt Street and were bordered by Ecorse and Southfield Roads. The children in this picture represent many of the pioneer families.

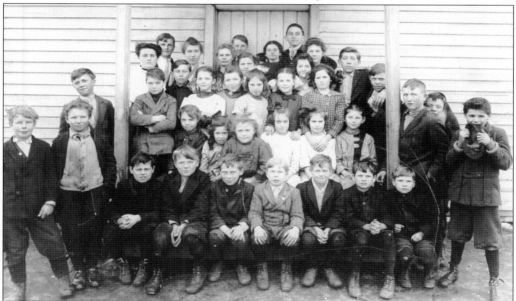

This picture was most likely taken after 1915. The class is standing by the wooden one-room schoolhouse built in the 1880s. Town lore tells of the pioneers who built the schoolhouse in one day. The women provided food and ran errands for the men. After the school was finished, the pioneers had a party. The school was known to be drafty and cold. Education has always been an important part of Allen Park's history.

"See the fox run!" is written on the blackboard in the Lapham one-room schoolhouse in a picture taken between 1912 and 1916. Students could attend school from kindergarten through eighth grade.

This picture once belonged to Valley Durand Becker. Clothing indicates cooler weather and dates the picture to around 1915 to 1920. The cement sign built into the one-room school read, "Ecorse Township, Lapham School, District Number 9." Ken Lieber Jr. and his father stored the sign for many years. It is now is the collections of the Allen Park Historical Museum.

36

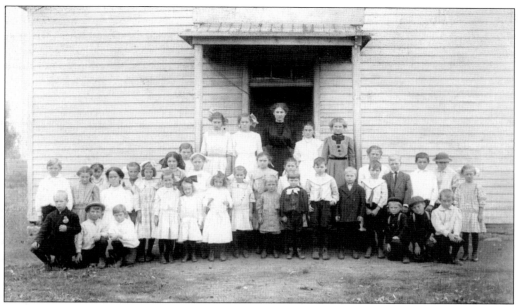

This photograph from the collection of Louis Backhaus shows another group of schoolchildren from about 1912. Allen Park residents have always shown interest in the education of children. No one knows what happened to the bell that rang in the tower to let the children know the school day was about to begin. Many old-timers say that it was taken to Camp Wakanda, the Boy Scout camp in Johannesburg, near Lewiston.

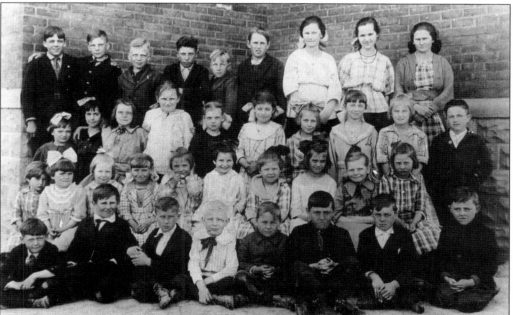

The first Lapham one-room schoolhouse built of wood around 1888 was demolished, and a new brick schoolhouse was built close to the same spot on the corner of Ecorse and Allen Roads. This picture was taken in 1921. Local lore tells that farmers waited to salvage the materials from the old school when it was torn down.

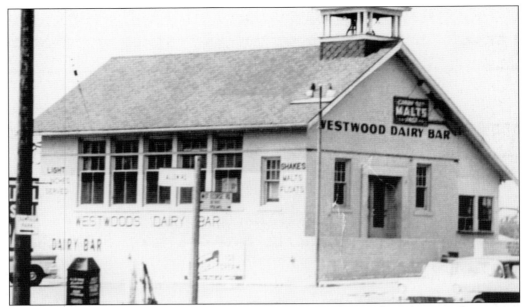

The Westwood Dairy Bar is remembered by many Allen Parkers. When the second one-room schoolhouse was no longer used as a school, it became the offices of the Village of Allen Park. It is best remembered, though, as the Westwood Dairy Bar. Residents remember going to the restaurant for malts and to hear music in the 1950s. The building was demolished in 1961, and today a gas station stands in its spot on the corner of Allen and Ecorse Roads.

The elementary schools in Allen Park are named after pioneer families who donated land and money. Pictured here are Charles and Clara Lindemann, who funded construction of Lindemann Elementary School, opened in 1952. The Lindemann farm was on the corner of Southfield and Allen Roads. In 2002, over 40 members of the Lindemann family attended the celebration of the Lindemann school's 50th anniversary.

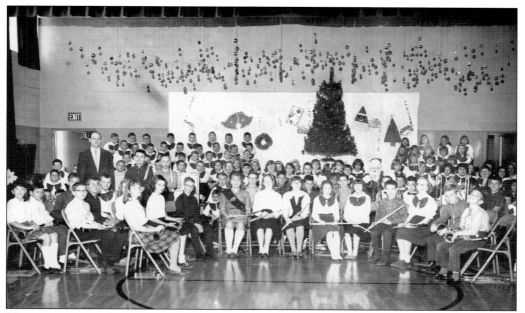

This picture was taken in the gymnasium of Arno Elementary School. The Christmas concert was a tradition at the school. Brothers Herman and Fred Arno financially supported the building of the school, which was opened in 1949.

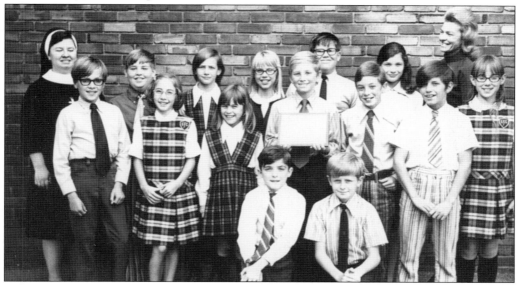

This class picture from St. Frances Cabrini Elementary School was taken in the 1960s. St. Frances Cabrini Church was the first church in America to use the name of the first American saint, Frances Xavier Cabrini. Fr. Claire Murphy worked endlessly to provide the Catholic community with a church, auditorium, shrine, rectory, convent, and school. The priest did not want to burden the parishioners financially, so the Cinderella Homes project was created. The church sold bricks for 50¢, and each gave a chance to win one of the homes built on Southfield Road, near the Southfield Expressway. The church was built on the Theeck farm on Wick Road, which was purchased for $1,000 an acre.

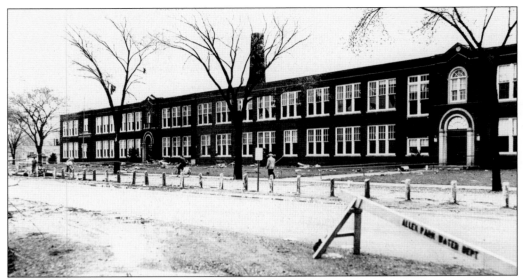

This is North Junior High School on Allen Road after the tornado of 1957. The right side of the new Lapham School was built around 1924 with additions made in 1929. In 1931, the school board appointed Chester G. Sudman as full-time superintendent. Under his administration, additions were made in 1944. Sudman's dream of a new elementary school was never realized; he died unexpectedly in 1946. Sudman Elementary School on Philomene Street between Cortland and Kolb Avenues was named in his honor. The school is gone, but the land became Sudman Park.

In 1959, this picture was taken at Riley Elementary School located on Moore Road near Vine Street. The school was named to honor Wilford Riley, who once was a one-man police force operating from his home on Thomas Street. In 1927, he was appointed police chief and held the job for 24 years.

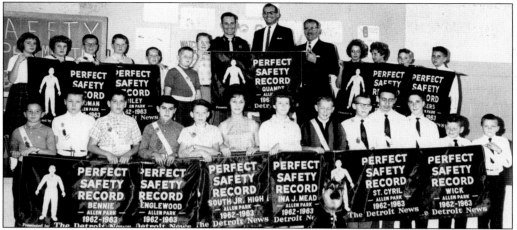

Perfect safety records awards were presented by the *Detroit News* on October 14, 1963. Three school districts serve Allen Park: Melvindale–Northern Allen Park; the Heintzen or Southgate district, a small section in the extreme south; and the Allen Park public school system, serving the majority of the city. Arno, Bennie, Lapham, Lindemann, Riley, and Sudman schools were named in honor of important figures in Allen Park history. Other Allen Park schools included Englewood Elementary, Wick Road Elementary, South Junior High School, North Junior High School, and Allen Park High School. Melvindale–Northern Allen Park schools included Mead, Quandt, and Rogers Elementary Schools and Strong Junior High School. St. Frances Cabrini Elementary and High School, St. Cyril Catholic School, Inter-City Baptist School, and Mount Hope Lutheran Christian Day School were the parochial schools.

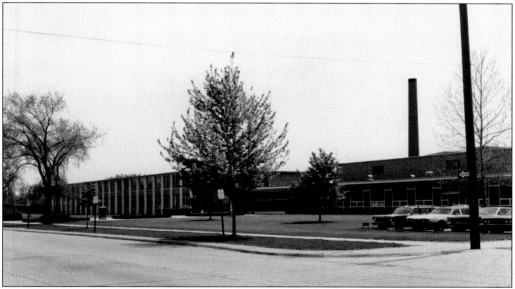

The Lapham School on Allen Road went through eighth grade. To receive a high school education, students traveled to Melvindale or Lincoln Park High Schools and Southwestern High School in Detroit. Students traveled to Ecorse, River Rouge, or Taylor to attend parochial schools. Soon the other school districts became too crowded to accept students from outside their cities. Allen Park High School opened its doors in 1955, ending the worries of parents whose students traveled to schools in other towns.

Allen Park High School was a welcome addition to the village of Allen Park. Even when relatively new, it was rich in tradition. The school colors, green and white, were selected by the first student council. The school newspaper was founded by Amy Keppen. First called *Potpurri*, then *Allepahi*, the name *Jaguar Journal* is still used. The emblem of the jaguar was selected and put to a student vote by Thomas Ludtke, who graduated in 1952. The pool was dug by nine members of the 1961–1966 classes.

The student store, a new concept at Allen Park High School, prepared many young adults to be successful in the business world in the 1960s. The student store still exists today. The high school business classes in 1955 had new typewriters and business machines from that time period. Today modern computers are used.

In 1957, Ken Egger was part of the basketball team at Allen Park High School. Sports have been important in the schools and the city. Today the Jaguars are known affectionately at the "Jags." The "new" Lapham School on Allen Road housed kindergarten through 12th grade until the high school was opened in 1955. In 1952, the high school rowing team won the national championship. Since then, every sport at the school has had championship teams at one time or another. The varsity football team is one of the best in the state. Many of the players go on to play at Big Ten schools. The Bulldog Junior Football League is often credited for grooming young boys in football.

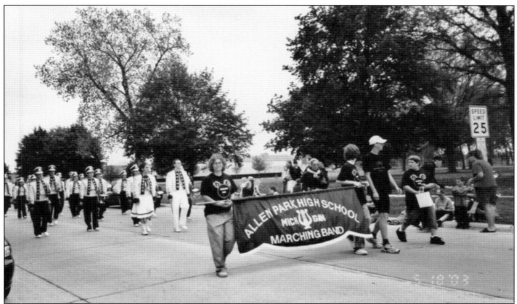

The Allen Park High School marching band performs at a Memorial Day parade. The alma mater of the high school was written by Gale Russell and put to music by Eugene Dyer. Gay Donovan, one of the first cheerleaders at the school, selected the fight song. The song is the "Washington and Lee Swing" march. The first verse was original and the second verse was written by Mrs. Albert J. Reed.

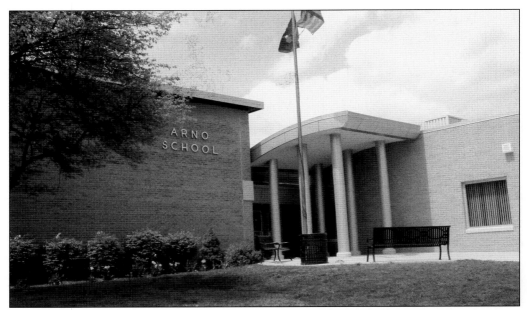

Arno Elementary School, located on the corner of Colwell and Fox Streets, was opened in 1949, three years after the Sudman Elementary School opened. The school had 12 classrooms with additions made in 1953 and 1957. The first principal was John Wysoski. The baby boom after World War II prompted the opening of most of the elementary schools in Allen Park. Arno was featured in a magazine called *National Architectural Forum* as one of the two outstanding new schools built in Michigan at that time.

The Bennie Elementary School was opened in 1954, named in honor of Scott-born president of the board of education Alexander Bennie. Alec, as he was known, played an instrumental part in the building of schools. Bennie Elementary was built on Champaign Street by the railroad tracks. In 1959, 8 classrooms were added to the original 12. The first principal was Edward Welsh.

Lindemann Elementary School opened in 1952 and soon became the largest elementary school in the Allen Park public school district. The school on Carter and Wick Roads had 12 classrooms with additions in 1954 of 12 more classrooms and 8 more in 1960. Lindemann facilities included solar windows and a health and exercise room that would help aid the young victims of polio. The first principal was Harry Jones.

Built in 1954, this school was known as South Junior High School and was one of two junior high schools, the other being North Junior High School. Today it is known as Allen Park Middle School. North Junior High was once the old Lapham School located on Allen Road, built in 1925; it has been remodeled and is currently an office complex.

Allen Park Community School adjoins the Allen Park Board of Education in the building that was once Riley Elementary School. Allen Park Community School offers a special program for high school–age students.

In March 2003, history was made in Allen Park when voters approved two bonds to revamp school buildings and upgrade technology. The high school needed much special attention. On November 15, 2006, the modernized Allen Park High School was rededicated. Many special events took the crowd back to 1955. A 1957 Chevrolet was parked in front of the school along with floodlights announcing the celebration.

For years to come, residents of Allen Park will benefit from the endeavors of R. Douglas Pretty, former superintendent of Allen Park public schools. Pretty was instrumental in passing a bond in 2003 that would bring school buildings up to date and give the city the gift of the Allen Park Center for the Arts, a much-needed auditorium dedicated on November 15, 2006. Sara Schultz played "The Star-Spangled Banner" on flute, the Allen Park High choir and marching band performed under the direction of Kristi Kruger, and the class of 1955 performed with the Allen Park High School Drama Club. A ribbon-cutting ceremony was held, with Pretty and superintendent Dr. John Sturock present, both graduates of Allen Park High School.

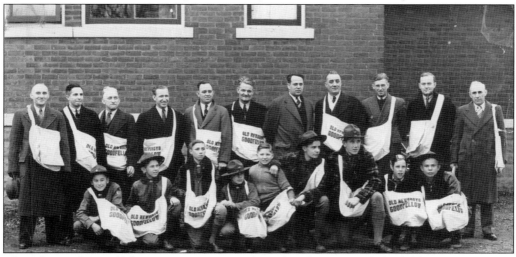

The Allen Park Goodfellows organization was formed in the 1920s to help children at Christmas. The Goodfellows collection bags in this picture refer to "Old Newsboys." The Newsboys of Detroit still use the name. These men were leaders in the village of Allen Park. The volunteers are standing outside the Lapham School, the one-room brick schoolhouse on Allen and Ecorse Roads that was being used as the village hall.

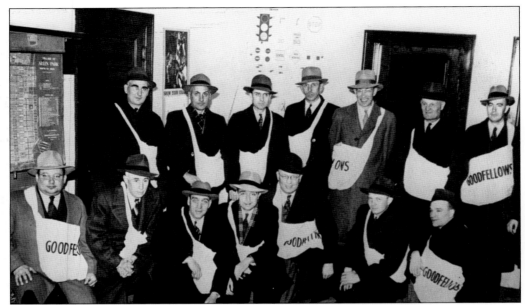

This group of Goodfellows includes Stanley Roulo, Etril Leinback, Henry V. Herrick, Joseph Purcell, Leo Menard, Charles Pretty, Wilford Riley, Stanley Burbank, and some unidentified men. The men are inside the old Lapham one-room schoolhouse that is now used as the village offices. "No child without a Christmas" was the motto of the Goodfellows. Many recipients have fond memories of receiving candy, nuts, oranges, socks, and toys from the men who belonged to this group.

The Allen Park Goodfellows are pictured in 1982. The motto is now "No child, needy family or senior citizen without a Christmas." Most of the Goodfellows in this photograph had parents who received Christmas help or received help themselves, prompting them to volunteer. The Allen Park Goodfellows is one of about five groups that still operates in the Downriver area. Pictured in the third row from left to right are Don Eiden, Julius Dazy, and Harry Healey. Dazy has been active with the group for over 50 years. In the back row is Randy Broglin, who has been president for over 24 years.

This picture, taken in 1959, probably at the corner of Goddard and Allen Roads, shows the organizations active in Allen Park at the time. The Lions Club, Allen Park Chamber of Commerce, Kiwanis, Rotary, Knights of Columbus, Masons, Soroptimists, American Legion, and Disabled American Veterans were some of the groups represented. Today many of these organizations still exist.

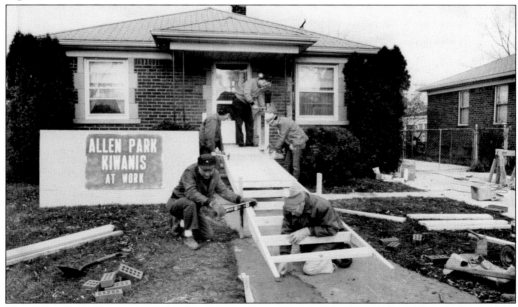

The Allen Park Kiwanis was the first service organization to be founded in Allen Park, in 1939. Three members of the Allen Park Kiwanis, Dick Penberthy, Tony Mettler, and Jim Soltesz, went on to be elected to serve as governors of Kiwanis International for the state of Michigan. The Kiwanis has an annual peanut sale to earn money to fund community projects. This group is installing a handicapped ramp in the 1950s.

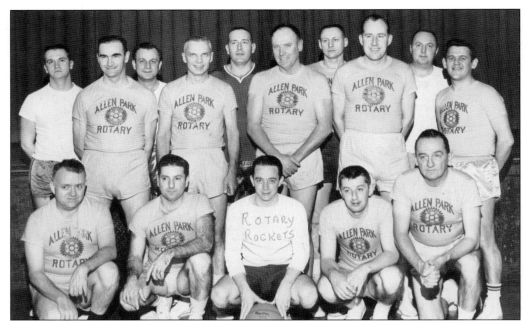

The men in the Rotary organization are usually business owners and leaders in the city of Allen Park. The group was founded a few years after the Kiwanis. Through the years, it has had many different projects. Today one of its programs is reading programs for children in the elementary schools.

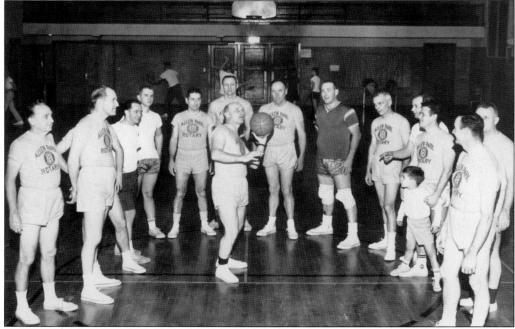

Rotary members are playing basketball in the gymnasium of the North Junior High School on Allen Road. Three of the men in the picture are Leaver, Hinds, and Dunn. The year is probably close to 1959.

In January 1946, 20 Masons assembled for the first time in the Presbyterian church on Park Avenue. Their goal was to form a lodge. The Masons signed a request to the grand lodge to grant them dispensation to operate as a lodge. Dispensation was received on December 22, 1948, and on May 25, 1949, the lodge was constituted, consecrated, and dedicated by the grand lodge. Lincoln Park, River Rouge, and Olive Branch were the sponsoring lodges. Charles Schaefer was the first president. The lodge is located on Ecorse Road. This picture shows a group of senior citizens attending a Masonic function.

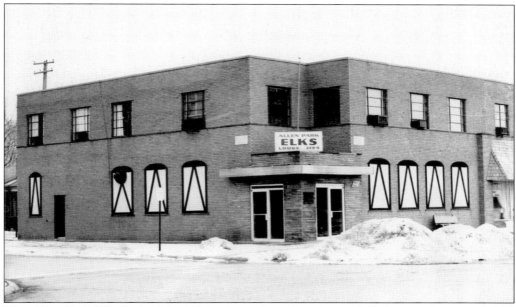

The Allen Park Elks Lodge No. 2194 is located on the corner of Philomene Street and Park Avenue. This building was one of the first libraries in the city of Allen Park. The Elks organization rented the building in September 1961. The building was rededicated as the Hinzmann Building and became the permanent residence of the group. For years, it has raised money to support awareness for veterans and handicapped children.

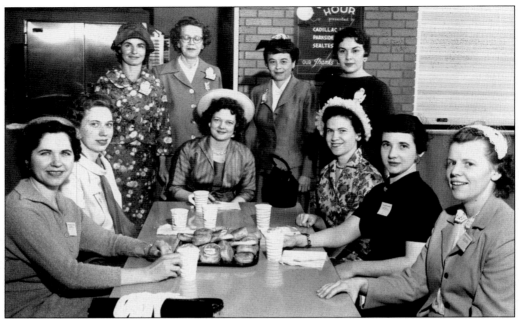

Soon after World War II, the baby boom caused parents many concerns for their children to be well adjusted. Women went to work while their husbands were serving the country. When the soldiers returned home, some wives wanted to stay in the work field. These women from the Allen Park Child Study Club are meeting to discuss many issues for the success of raising children.

In 1946, the Junior Chamber of Commerce was organized through the efforts of Nelson Heslip and Benjamin Goodell. Fourteen charter members signed. Known as the Jaycees, the group published the Jaycee directory, a booklet of information pertaining to Allen Park. Today the directories are valuable for historic research. The Jaycees were instrumental in projects such as Safetytown and Bowling for Burns. In the 1970s, the group chaired the ethnic festivals that were held in the ice arena. Women had their own chapter, the Jaycee Auxiliary. They had many projects of their own that contributed to the city.

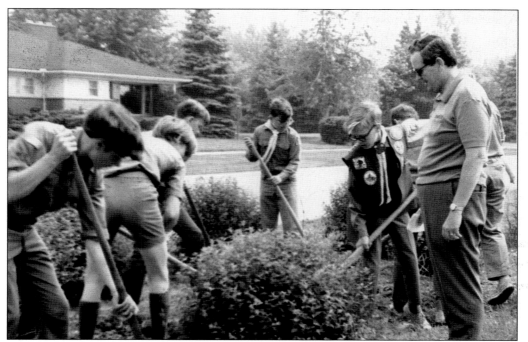

Boy Scouts under the direction of beautification commissioner Jack Rourke are shown giving service to the city. Boy and Girl Scout Troops have played an important part in Allen Park history.

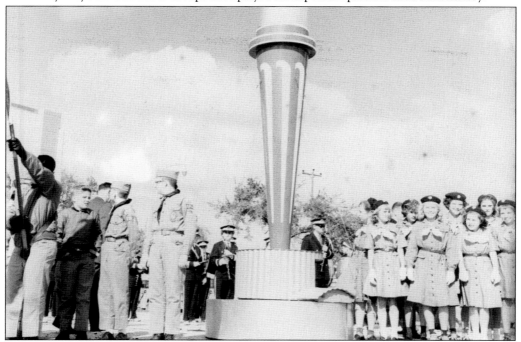

In October 1961, Scout troops gather near Southfield Road for the lighting of the torch for the United Foundation. The Allen Park High School band is in the background. The Boy Scouts are presenting the colors in this picture.

This is the first Girl Scout troop in Allen Park. Troop 2069 was awarded certificates for completing a civil defense class in 1963. Civil defense preparation was an important part of life during the years after World War II.

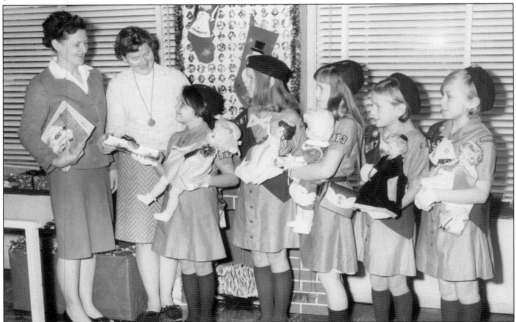

Allen Park policewoman Marie Von Bergen is showing appreciation to a group of Girl Scouts. The numbers on their uniforms indicate that the girls came from different troops in the city. The girls dressed dolls in December 1967 to be given to the Allen Park Goodfellows. It was a tradition for women and girls to dress dolls for the Goodfellows to be displayed in business windows.

Three

A DAY IN TOWN
STORES, BUSINESSES, AND STREETS

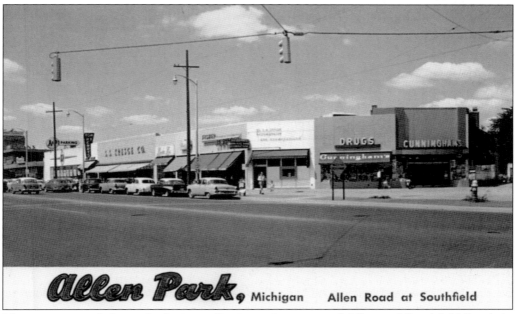

This rare postcard shows the business district at the corner of Allen and Southfield Roads in 1959. Cunningham Drug Store, the S.S. Kresge dime store, and the A&P supermarket were favorites for downtown shoppers. (Courtesy of Frank Canning.)

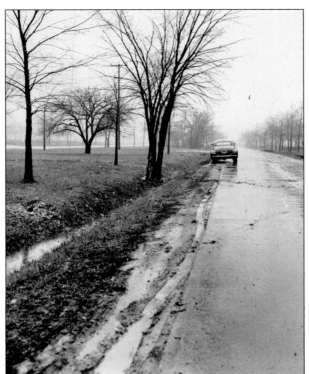

This undated picture of what is now known as Southfield Road shows a faint image of what appears to be a barn on the right-hand side of the road. Southfield Road was also known as State Road and in Allen Park as St. Cosme Line Road.

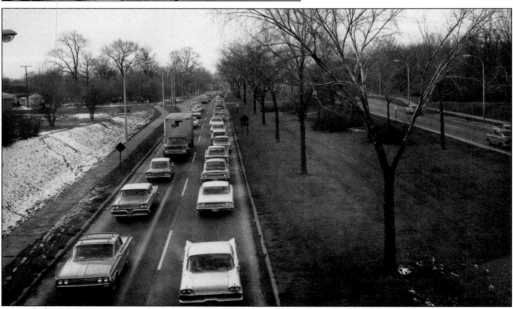

This traffic jam occurred on January 29, 1965, on southbound Southfield Road. The picture was taken from the Detroit, Toledo and Ironton Railroad overpass. Behind the wooded area on the side of the road going north was the Montgomery Ward distribution center. The cleared land on the right was the much-disputed land that the Ford family gave the city to build a new city hall. Political disagreements left the land vacant for years. The land was reclaimed by the Ford Motor Company.

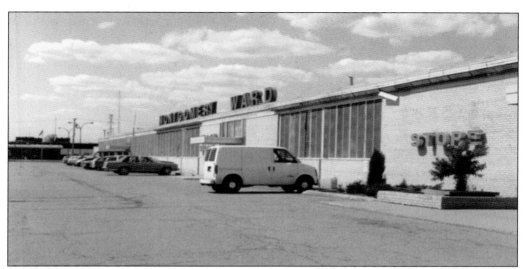

When the Montgomery Ward and Company headquarters in Chicago informed the city officials of its decision to build its first distribution center on Southfield Road in Allen Park, it was a major victory. The original mail-order house in America, founded in 1872 by Aaron Montgomery Ward, had become a retailing giant. The warehouse, opened in 1959, serviced five states. The complex included catalog, service, and credit departments, a retail store, a gas and service station, and catalog overstock and appliance outlets. More than 900 people were employed on the premises. As this style of distribution became more costly, the facility closed in the mid-1980s. In January 2001, Montgomery Ward decided to close its doors nationwide forever.

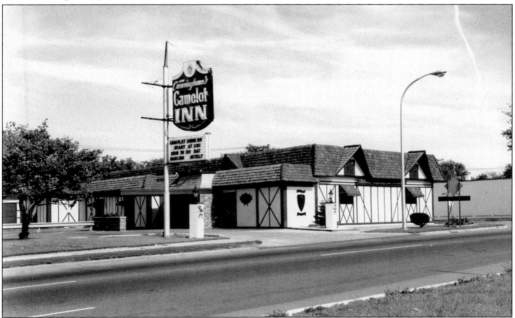

In the 1960s, customers came from near and far to enjoy the food and drink at the Camelot Inn located on Southfield Road near Roosevelt Street. The owners, Jim and Christine Cunningham, lived in Allen Park and were active in the city. Today it is known as B. Boomer's Sports Bar and is still a popular spot.

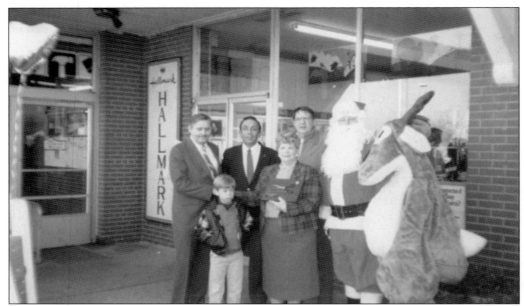

The grand opening of the Browsery Hallmark store on Southfield Road was held on December 13, 1980. Pictured in the first row are Britton Gibson and his mother, Jackie Gibson. In the second row from left to right are unidentified, Mayor Dominec Boccabella, and Bill Gibson; Santa and the reindeer are unidentified. Jackie previously owned a card and gift shop on Park Avenue in the 1970s, making her one of the first women in Allen Park to own a business.

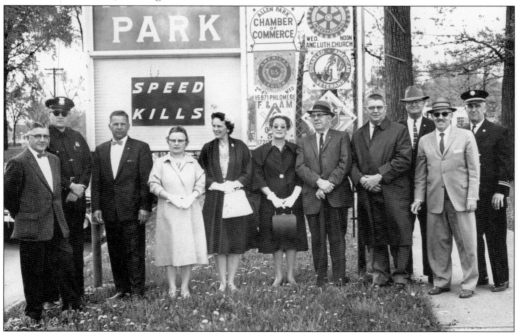

A Welcome to Allen Park sign appears on Southfield Road near Allen Road in May 1961. The occasion was Mayor's Exchange Day, which was part of the Michigan Week festivities. Michigan Week is still a tradition.

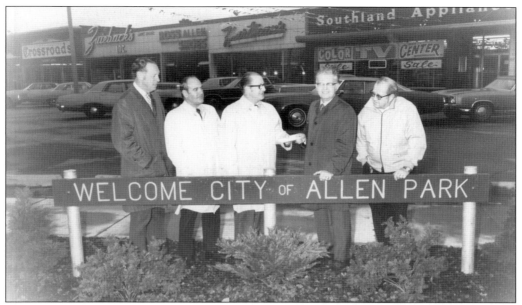

This picture was taken on November, 10, 1972, at the South-Allen Shopping Center, which held its grand opening in the 1950s. Pictured from left to right are Don Pretty, Harold Duda, Mayor Frank J. Lada, Levon King, and an unidentified person. Over 20,000 people attended the grand opening, and Allen Park police and Wayne County sheriffs directed traffic on Southfield Road. WXYZ-TV recorded the event. Wrigley's Supermarket is at left.

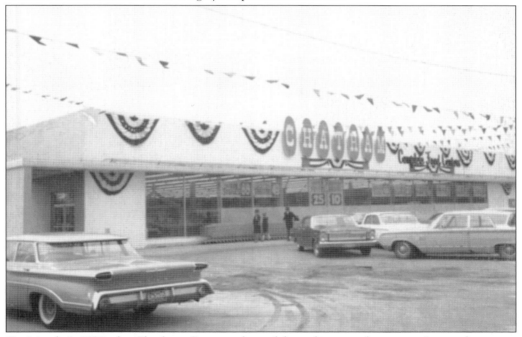

On March 1, 1970, the Chatham Supermarket celebrated its grand opening. It soon became a favorite. The store stands where Wrigley's Supermarket once stood in the South-Allen Shopping Center at Southfield and Allen Roads.

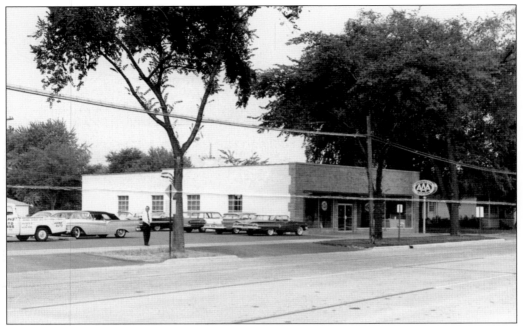

This picture from the 1960s shows the Automobile Club of Michigan offices in Allen Park on Southfield Road. The home on the right side of the picture once belonged to Hugo Klann, whose wife was Anna Theeck Klann. The home no longer stands.

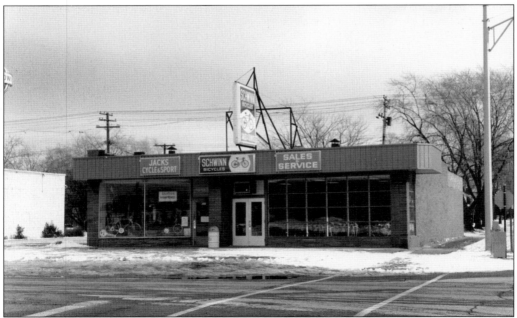

Park Avenue was another street that had a small shopping area that was close to Southfield Road. This picture of the Schwinn bicycle shop was taken in the 1970s. Down the block from this store was once Park Lane Children's Wear, and still in business are McNally's Shoes and the Fancy Pastry Shop.

This picture was taken when the funeral home on Park Avenue was known as the Thompson Funeral Home. Today it is known as the Weise Funeral Home, owned by Robert J. Weise, his son Robert A., and his brother Gary. Another brother, John Weise, left the family business when he was elected clerk for the City of Allen Park. It is one of three funeral homes in Allen Park. The Martensen Funeral Home is on Allen Road near Goddard Road, and the Voran Funeral Home is on Allen Road close to Southfield Road. In the early days of Allen Park, homes were used for viewing the deceased. Many Allen Park pioneer families were buried in Woodmere Cemetery in Detroit and West Mound Cemetery on Eureka Road in Taylor. The French settlers were buried in a Catholic cemetery on Second Street in Ecorse.

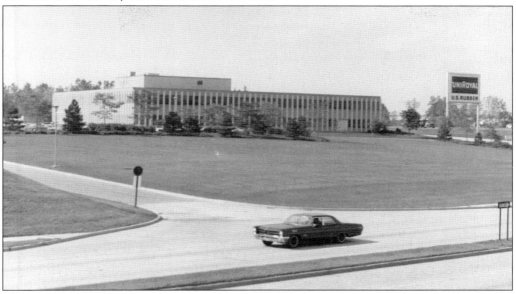

The UniRoyal building stands near Enterprise Drive. The giant tire would eventually stand in the background close to the Edsel Ford Expessway, named in honor of Henry Ford's only child, Edsel. The Frito-Lay plant, the Heublein liquor plant, and the Ramada Inn were also in the industrial complex.

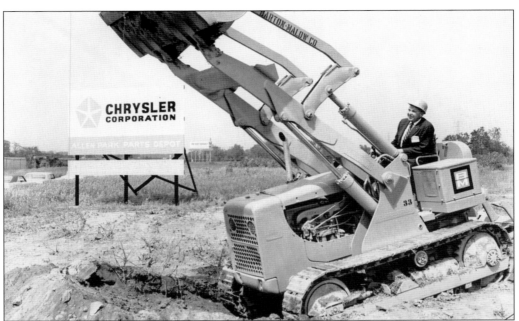

The groundbreaking ceremony for the Chrysler Corporation Allen Park Parts Depot close to Outer Drive Road is shown in this picture. Breaking the ground is Arnold Malow, founder of Barton-Malow Construction Company. Allen Park was developing an industrial area on Enterprise Drive close to the Edsel Ford Expressway.

This picture shows the Goddard–Pennsylvania Railroad grade separation looking west. The Goddard Road area had a lot of open land. At one time, plans were made to build an airport in that area. Instead Metropolitan Airport was built in Romulus.

This picture shows what would eventually become the picnic area for the Park Colony Swim and Tennis Club that was built on Goddard Road. The private membership club gave many families a chance to enjoy summer right at home. The club had a successful swimming team that competed with other cities. The tennis courts were used by young and old, and there were daily activities.

For many years, Detroiters would take rides to the open roads in Allen Park on warm summer Sundays. This road is Enterprise Drive, leading to what was once an industrial area. Enterprise Drive could be seen as one drove on the Edsel Ford Expressway, known today as Interstate 94. Today many of the industries that came in the late 1950s and early 1960s have moved to other locations.

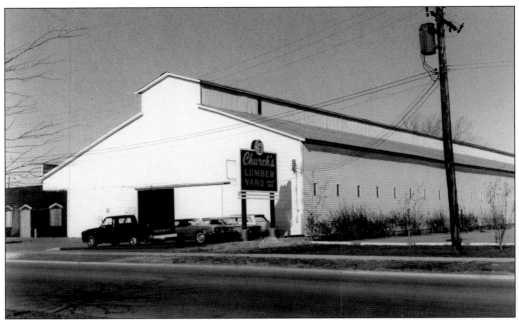

The Church's Lumber Yard was a favorite place for the men. A fire destroyed the business in January 1973, and it was never rebuilt. It its place today is the Leo Paluch Senior Citizens' Apartment Building. The lumberyard was on Champaign Road across from what is now the Father Saylor Knights of Columbus Hall.

This picture was taken near the Balas Steel Company located on Roosevelt Street. The other businesses on this street at that time were the National Food Store and the Union Furniture Store. The Allen Park Fire Department is not far from this spot today.

Local realtor and historian Lynn Ketelhut took these pictures in 1996. This section of Roosevelt Street shows the Park Athletic Supply Store and Roosevelt Bowling Lanes. The history of this street has already been altered since this picture was taken, as the drive-in bank down the street has been closed.

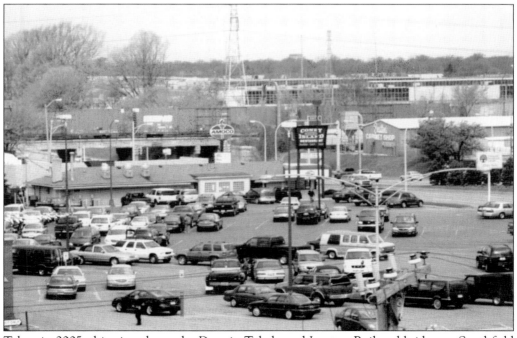

Taken in 2005, this view shows the Detroit, Toledo and Ironton Railroad bridge on Southfield Road. The bridge, built in the mid-1900s, is another historic site in Allen Park. The large building across the railroad track is the former Montgomery Ward warehouse and distribution center.

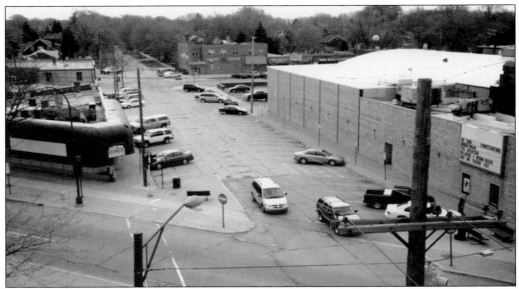

This shot, taken in 2005, shows one of the most remembered eating establishments on the left-hand side, the former Triangle restaurant. The restaurant was known for its corned beef sandwiches. On the right is the Allen Park Theater, once owned by Nicholas George, and Park Avenue is in the background.

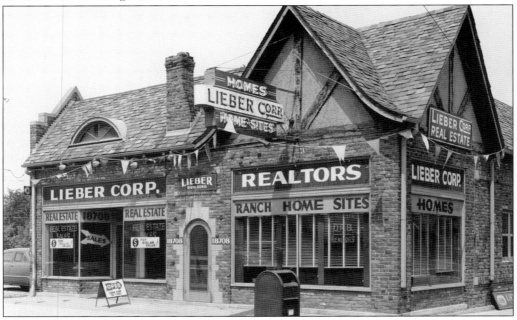

The Lieber Corporation was founded by Ed Lieber, who brought his nephew Ken W. Lieber from Kansas to the Detroit area to work with his business. Ed and Ken were land developers, under the name of the Lieber-Norton Corporation. The picture of this building was taken in 1950. The Liebers had owned the building since 1932 but did not move in until 1941. At one time, the west side of the building was the Szuch grocery store, and the other side was a restaurant. Ken H. Lieber, Ken's eldest son, continues the business today.

The Tasty Creme Donuts shop on Ecorse Road was founded in 1958 by Ottie and Roxie Pankey along with their son, Wayne. Many mayors, city officials, businessmen, and citizens share stories of the city over a cup of coffee at Tasty Creme.

The grand opening of the Tasty Creme was held in October 1958. It soon became one of the favorite doughnut shops in the area, known for its apple fritter doughnuts and fried fruit-filled pies. When the shop was opened, coffee sold for 10¢ a cup, and doughnuts were 49¢ a dozen. Tasty Creme Donuts is still in business today and has the same atmosphere as it did in the 1950s. Employee Jo Pendley, who has worked at the shop many of the years that it has been in business, remembers many of the customers who frequented the shop through the years. Next door is the Wish Bone Restaurant, known for its Broasted Chicken.

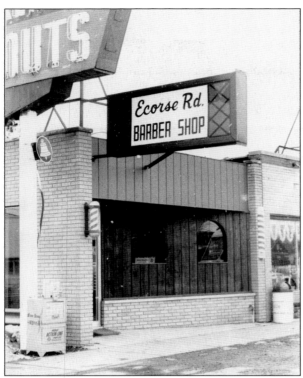

The Ecorse Road Barber Shop, once called Sir Joseph's, on Ecorse Road was opened in the 1970s. Owner Joe Mallia started his business in a small shop next to Tasty Creme Donuts. The original barber poles on the building shown in this picture were stolen one day, never to be recovered. The front of the shop has been changed.

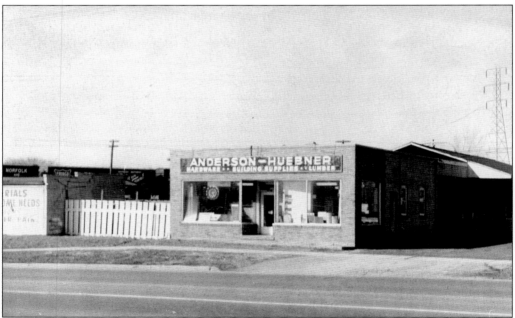

Anderson-Huebner Hardware on Ecorse Road has supplied many a handyman with materials for improving the home for many years. The Andersons lived for many years on Balfour Street. Elmer Theeck, who is from the pioneer family of the same name, was employed at the store for years. Customers would take the time to hear Theeck's countless tales of early Allen Park.

It was an exciting week in October 1961 when Mayor Clarence L. Lichtenberg, on the right, gave the City of Allen Park's proclamation to the Thunderbowl Lanes and Arena, declaring it the largest facility of its type in the Midwest and also declaring that it was Detroit Thunderbirds Week, as the Detroit Thunderbirds would represent Detroit in the National Bowling League.

The event included a parade and many dignitaries. October 13, 1961, marked the beginning of many exciting events that would take place at the Thunderbowl Lanes and Arena for years to come. In this photograph from left to right are three unidentified men; George Prybyla, the owner of Thunderbowl; Michigan governor William Milliken shaking hands with Mayor Frank J. Lada, and Jack Rourke and his wife, Claudia.

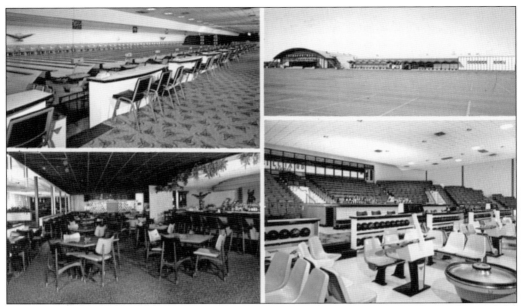

This postcard of Thunderbowl Lanes and Arena shows the ultramodern facilities of one of the largest bowling establishments in the Midwest. There were 54 lanes in the main building and 20 lanes in the arena. The dining, banquet, billiard, and meeting rooms in the complex would accommodate almost 800 people. The parking lot could handle over 1,200 automobiles. The state-of-the-art building brought many famous bowlers to Allen Park, and many tournaments were televised from the home of the Detroit Thunderbirds.

It was a big event in a child's life to go to the Morris Store to choose the toys that would go on a Christmas list for Santa. This Morris Store was on Allen Road, a few blocks from Southfield Road. On Saturday mornings, many homeowners found themselves buying items needed to improve homes and yards.

After the Morris Store closed its doors, the Kiddie Land Stores became the new spot for items for children. Soon enough, toy giants such as Toys "R" Us came into the area, putting an end to the smaller shops.

This street scene on Allen Road in what was known as downtown shows a strip of stores that are just memories today. The picture was taken in 1971. Before the large malls were built, shoppers could find just about anything they needed without leaving the town. Today the famous Moro's Restaurant is in this block.

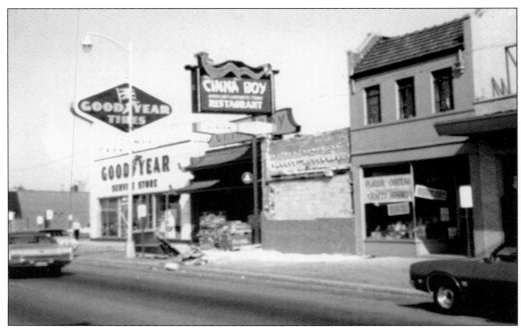

China Boy Restaurant, shown in this picture, brought many people to Allen Park who appreciated Chinese food. The restaurant featured exotic drinks and some of the best Chinese cuisine in the area. A fire destroyed the business, and it was never rebuilt.

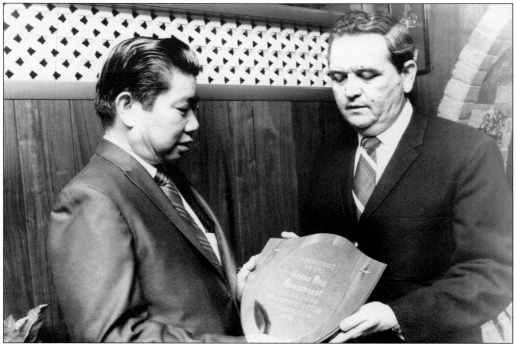

Tommy Wong, owner of the China Boy Restaurant, is accepting an award from Jack Rourke, who served on the Beautification Commission. The year of the award is 1971.

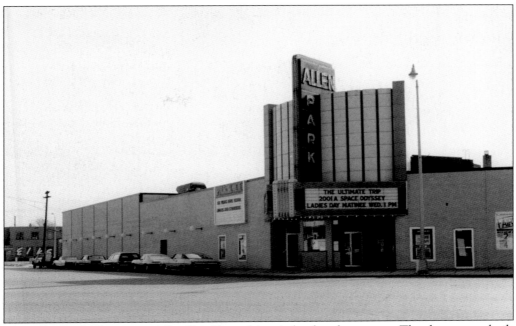

The Allen Park Theater on Allen Road has a historic landmark marquee. The theater was built and owned by Nicholas George. George was a Greek immigrant who built many other theaters and drive-in theaters in the Downriver area. The building is still in operation today.

This picture was taken in 2005 and shows the Allen Road business district from the roof of the Red Fawn Banquets facilities, formerly Albert's Supermarket. New light posts and landscaping were recently added to the business area.

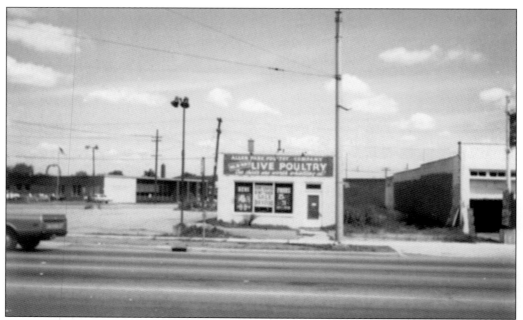

The Allen Park Poultry Company stood on Allen Road close to Roosevelt Street. The slogan on the sign reads, "Our Chicks Are Worth Whistling At." The sign in the window says, "For Lease, Rent, Sale or Trade." The days of specialty stores were ending with supermarkets on almost every corner.

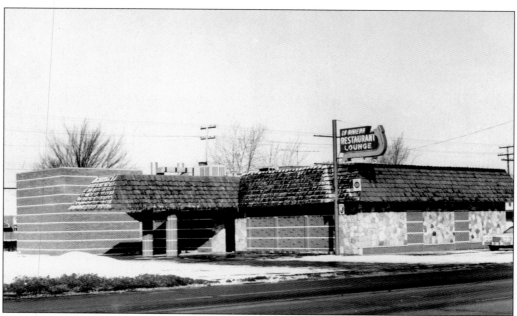

The La Riviera Restaurant and Lounge was opened by Tullio and Josephine Eusani in 1955. Tullio and Josephine were among the many Allen Parkers who came from Italy. La Riviera was a restaurant that many would choose to celebrate a special occasion.

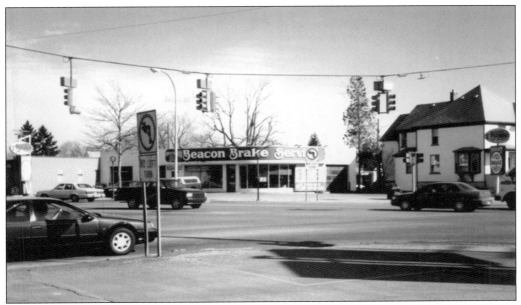

This intersection is at Allen Road, Ecorse Road, and Roosevelt Street. The Beacon Brake Service is in a building from the 1930s and is next to one of the three Dasher family homes that were built in this area. The Louis Dasher home, built in the late 1920s, was used as a funeral home, beauty shop, and antiques shop. Leo Kushel, a Downriver artist, and his wife lived in the home at one time. A local legend told by a few previous owners is that it is haunted.

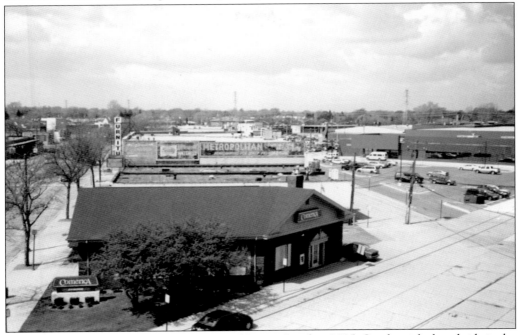

This view shows Allen Road looking toward Ecorse Road in 2005. On the right-hand side is the Frank J. Lada Arena and Recreation Center. In the middle is the Metropolitan Furniture Store that has served Allen Park for many years.

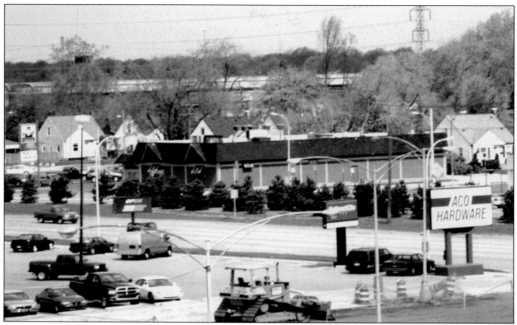

This photograph of Southfield Road going north shows the former Camelot Inn, which is now B. Boomer's Sport Bar. When Allen Park was a village, Southfield Road was known as St. Cosme Line Road. This photograph was taken in 2005.

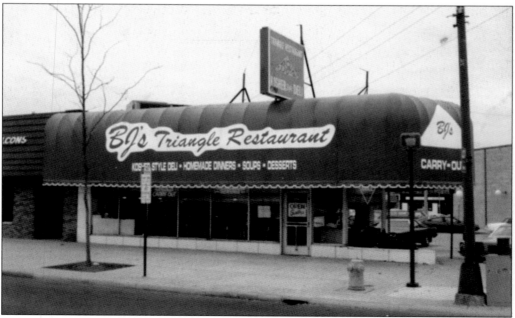

This pie-shaped building has always been a busy spot. In the 1940s, the restaurant was known as Maury's Triangle Restaurant. This photograph was taken by George Donigian, who bought the business from his friend B. J. Swiss. Donigian and his wife, Connie, bought the restaurant in the 1980s. B. J.'s Triangle Restaurant is the Allen Park Diner toady.

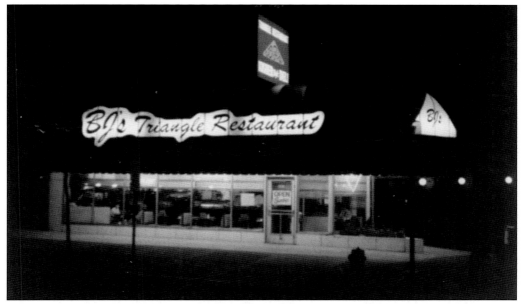

This night scene at B. J.'s Triangle Restaurant was taken in the late 1980s. The previous owner, B. J. Swiss, and the owners at this time, George and Connie Donigian, were all teachers at Allen Park High School. Many of the workers in the restaurant were students from the school. One of those students, Mark Greathead, principal of Lindemann Elementary School, has good memories of those days at the "Triangle," as it was nicknamed.

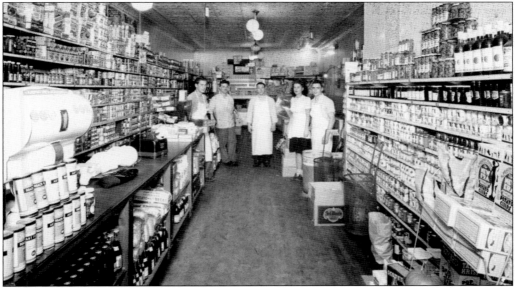

This picture of Borbely's, the first full-line market in Allen Park, is one of the most popular pictures in the Allen Park Historical Museum collections. Anton Borbely, who had operated a grocery store and meat market in River Rouge for many years, grew fond of Allen Park's thriving little community. In 1929, he purchased a building for his store. It is considered the first business to be established in Allen Park. His building was expanded two times, and American Legion Post No. 409 is in what was the enlarged building.

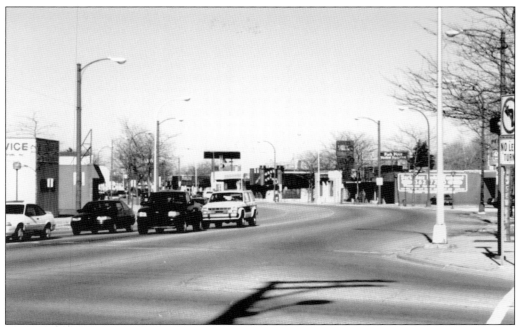

This view of Allen Road near Ecorse Road and Roosevelt Street was taken in 2005. In the distance is the Lion's Den, a favorite hair salon. Allen Road is one of the longest roads in the Downriver area and is named after Lewis Allen.

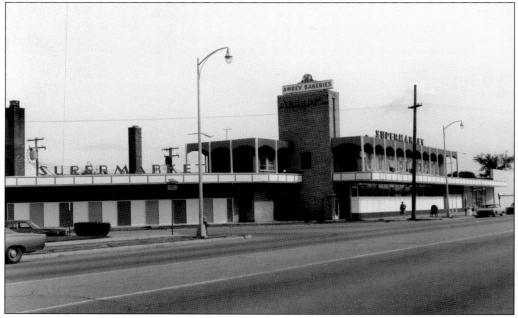

Albert's Supermarket always had a special place in the hearts of Allen Parkers. In 1936, Albert Perrino and his wife started this market opposite Borbely's Supermarket. The store attracted shoppers from surrounding communities and Detroit. Allen Park residents were saddened when the Perrinos announced that they were closing the doors.

Four

A NEW LIFE
THE IMMIGRANT EXPERIENCE

The Hungarians were one of the largest immigrant groups in Allen Park. The greatest period of immigration occurred between 1870 and 1910. In 1956, the Hungarian Revolution against Communism rule and Russian oppression caused another major wave. Delray, an area in Detroit, became one of the largest settlements of Hungarians in Michigan and the United States. When developers advertised homes in Allen Park, Hungarians moved to the area in large numbers. Their influence has made a mark in this town's history. This picture of the Arnoczki family was featured in the *Detroit Free Press* with an article about their strudel shop. Pictured are Emma Arnoczki, her son John, and her daughter Helen Blessing. The Hungarian Strudel Shop moved from West McNichols Street in Detroit to Allen Park. It has been making the fruit-filled pastries for almost 50 years.

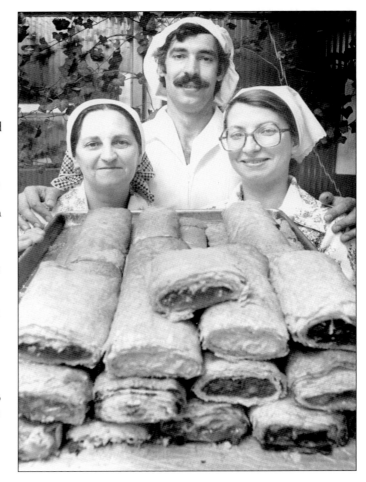

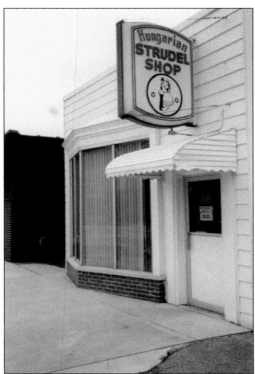

Fruit-filled strudels from the Hungarian Strudel Shop on Park Avenue are a favorite among Allen Parkers. Hungarians are known for their delicious pastries and cooking. Down the street is the Fancy Pastry Shop, which moved from Delray to Allen Park and is owned by Alex Kocsisko.

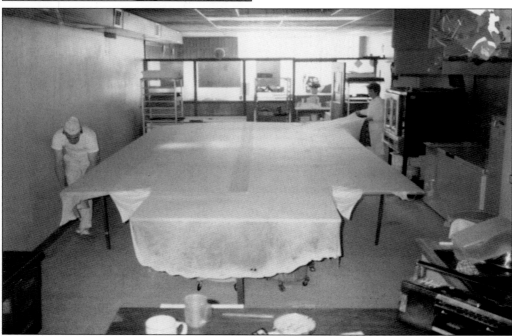

Strudel production is time-consuming. Dough is stretched over tables and pulled thin to make the pastry flaky and delicate. John Arnoczki and his sister, Helen Blessing, make the pastry daily according to Hungarian tradition.

Photographer Victor J. Racz moved to Allen Park from Delray and built the Racz Studio on Park Avenue not far from the Hungarian Strudel Shop. Victor is pictured with Elizabeth Horvath Racz and their daughter, Victoria. According to Elizabeth, the majority of the weddings photographed in the Detroit studio were Hungarian and Armenian. The Hungarians built the Hungarian Reformed Church on Allen Road. Services were held in Hungarian. Most Hungarians were Catholic but many attended the Presbyterian and Lutheran churches in Allen Park as well.

This wedding picture of American-born Hungarians, Julius and Rose Dazy, was taken in 1941. Julius was born in Delray, and Rose was born in Chicago. Julius and his parents moved from Detroit to a home in Allen Park next to the John Quandt farm in 1926. Julius worked on the Quandt farm from the age of 12 until he was 18. He apprenticed at the Ford Motor Company, was a tool and die maker, and was one of the first employees at the Willow Run bomber plant. After the war, he returned to work at the Ford Motor Company. His children, Robert and Priscilla, were raised with Hungarian traditions.

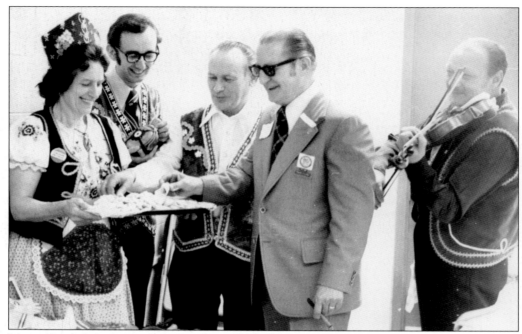

Mayor Frank J. Lada, an American-born Hungarian, is at the Hungarian booth at the ethnic festival in Allen Park. The Hungarian presence in Allen Park will long be remembered in names such as Borbely, Szalai, Balogh, Horvath, Papp, Baynai, Duda, and Toth.

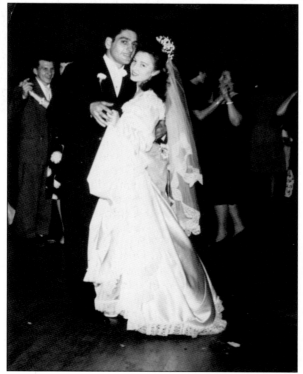

On October 11, 1947, George Bove and Phyllis D'Agostini had a large Italian wedding. Phyllis, who lived on Harrison Street, went to Melvindale High School. They were both American-born Italians. The parents of Phyllis were Nicola and Maria D'Agostini, who came to Allen Park in 1941. George went on to become an officer in the Allen Park Police Department.

Italians moved into Allen Park in the 1940s and 1950s. Italian-born Angelo and Santa Tucci, pictured in 1988, founded Tucci's Ristorante, the former Bona Fiesta Restaurant, in 1979. The restaurant on Allen Road near Southfield Road has hosted many famous guests, including Tom Lasorda, Ted Nugent, Guy Gordon, and John and Marilyn Turner. Santa does most of the cooking. One of the Tucci sons, Frank, was a councilman in Allen Park. Allen Park Italians are known for businesses in town and in other cities. Other Italian-run enterprises include the Allen Fruit Market, owned by the Tuccinis family; Tullio's La Riviera Restaurant, founded by the Eusani family; Scalici's Bar and Restaurant, owned by the Scalici family; the Wheat and Rye Restaurants, owned by the DaRonco family; and Roosevelt Bowling Lanes, owned by the Rossi family. Clemente's Bar, Restaurant and Bowling Alley in Lincoln Park is owned by the Clementes, and the Major's Restaurant, owned by the Riviera family, and the Giovanni Restaurant, owned by the Truant family, were two of the most famous eating establishments in Detroit. The Giovanni's restaurant is still a favorite today.

Many Italians who moved to Allen Park were from the Oakwood district of Detroit. Anthony Foresi, whose parents came from Italy, attended Southwestern High School in Detroit. After he graduated, he entered the Henry Ford Trade School in Detroit. Foresi went on to become an inventor and developer and owns patents on his golf training equipment. He takes pride in his Italian heritage and is considered a wine expert in Allen Park. He was elected to serve on the Allen Park City Council twice. There are many familiar Italian names in Allen Park history, including Boccabella, Nardini, Tuccini, Donofrio, Riviera, Scalici, Bellante, Carlini, De Angelo, Amore, Neapolitano, and Eusana.

The Irish of Allen Park love to celebrate the wearing of the green. This picture shows a group celebrating St. Patrick's Day. The girls in the first row are unidentified. In the second row from left to right are unidentified, Jerry Cavanaugh (the mayor of Detroit), Jack Rourke, Jim Cunningham, unidentified, and Mayor Frank J. Lada. A few of the familiar Irish names in town were Donleavey, Cunningham, O'Neill, Rourke, and Bowdell.

Omar and Theresa O'Neil probably had the largest Irish family in town. They had 12 children. Omar was on the city council in the 1960s and went on be president of the Southern Wayne Chamber of Commerce. Following in his father's footsteps, their son William was elected to the city council and became a state representative. The O'Neil family would entertain at their brother's St. Patrick's Day fund-raiser, which was one of the largest Irish parties in the city. Theresa was a founding member of the Allen Park Street Fair Committee.

Detroit had one of the largest populations of Armenians in the United States. Many of the Armenians who came to Allen Park were from southwest Detroit. A large group lived in Delray with the Hungarians. When the Hungarians made their move to Allen Park, so did the Armenians. Vahan Mouradian was born in 1902 in Sepastia, Armenia, now Turkey. This picture of Mouradian and his second wife, Almas, was taken in December 1946. They moved to Allen Park in 1947. His first wife, Armenuhi, the mother of his two children, Alice and George, died of cancer. All three were survivors of the massacre of one and a half million Armenians by the Ottoman Empire in 1915. Mouradian worked at the Ford Rouge plant in Dearborn. Many women received rolling pins made by Mouradian that were used to roll thin dough. Armenians use thin dough to make paklava, a sweet dessert layered with nuts that is enjoyed with small cups of Armenian coffee.

Mitchell D. Kehetian was born in southwest Detroit in 1930. His parents, Alice and Kaspar, were Armenian immigrants. Mitchell attended Southwestern High School in Detroit, showing an interest in journalism. When he was about 18 years old, he worked for his brother Nash in his service station located on Vernor Highway in Detroit. After that, he worked at the Ford Rouge plant—for one day. He soon made the decision that these jobs were not for him. In 1953, Mitchell went on to work for the *Detroit Times*. After it ceased publication in 1960, he went to work at the *Citizen-Journal* in Columbus, Ohio, and other Detroit suburban newspapers. In the 1970s, Mitchell joined the staff of the *Macomb Daily*, holding a variety of positions before becoming the managing editor. He has been awarded many writing and achievement awards at the state and national level during his newspaper career. Mitchell and his wife, Rose, were members of the Allen Park Jaycees, and during that time, he received awards for contributions to the Jaycees and the city. His daughters, Grace, Janet, and Karin, attended Melvindale High School. Mitchell's parents came to Allen Park every Saturday from Detroit to shop at Albert's and National Supermarkets. The visits to this town inspired him to raise his family here.

Five

COMMUNITY SPIRIT
CITY PLANNERS,
PROTECTORS, AND PLACES

Lewis Allen was born in Massachusetts in 1815 and raised in Detroit. Allen was a lawyer but never practiced law. Instead he lumbered 275 acres of land that ran from the shores of the Rouge River and ended in today's Allen Park where Thunderbowl Lanes and Arena stands on Allen Road near Outer Drive Road. He built a home on this intersection and on Allen and South Dearborn Roads in Melvindale but never lived in either of these houses. Allen and his wife, Julia Larned, lived on Alfred Street in Detroit, neighbors of influential Detroiters such as Joseph L. Hudson, the department store owner. During winter months, Allen hauled logs to his sawmill on the Rouge River. He cleared a lumber trail from the woods to the mill, calling it Allen's Road. It was later changed to Allen Road and is now one of the major roads in the Downriver area. This is the first time Allen Parkers will see a picture of Lewis Allen.

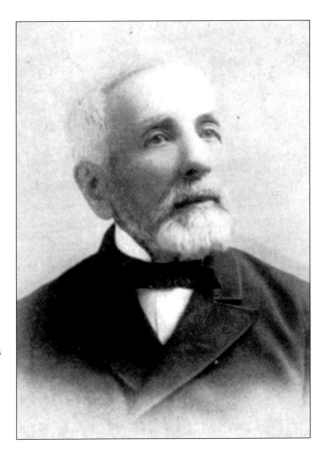

The seal of the City of Allen Park was designed by a young art student, Frank Lafferty. Frank was the son of city controller Barrett Lafferty. The seal was completed by Earl D. Carsten, owner of Carsten Products. The shield bearing five symbolic drawings topped by a spread eagle and enclosed in a circle bearing the words "City of Allen Park, founded 1927" tells a short story about this city. Allen Park was incorporated as a village in 1927 and became a city in 1957. The eagle indicates strength and vigilance, the stars and bars represent the basic unit of the United States, the English lion symbolizes the period that this area was under British rule, the fleur-de-lis has the same significance in regard to France, the tepee reveals that the site of Allen Park once was Native American territory, and the map marks the city's location with a dot on the lower right in Michigan. The seal was approved by the council under Mayor Clarence L. Lichtenberg.

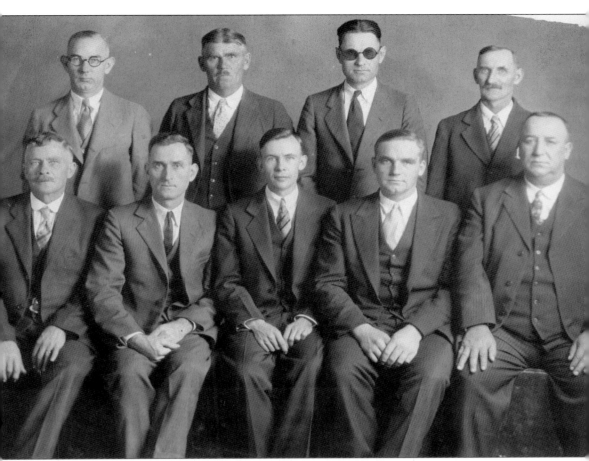

The original council of the Village of Allen Park is pictured in 1927. Pictured from left to right are (first row) Charles Schafer, councilman; Lester Boelter, treasurer; Frederick L. Schwass, president; Lloyd Quandt, clerk; and Frank Champagne, councilman; (second row) O. Dale Reynolds, councilman; Louis Backus, councilman; Charles L. Weigt, councilman; and Charles Lindeman, councilman. Through the years many individuals have contributed greatly to the progress of what was once a small rural township. The following men served as the leaders of this town: Frederick L. Schwass, first village president, 1927–1941; Etril Leinbach, Schwass's successor, 1941–1953; George Schafer, village president until Allen Park became a city in 1957; Osborne Pat Dunn, Allen Park's first mayor, 1957–1959; Clarence L. Lichtenberg, Dunn's successor, 1959–1963; Leo J. Paluch, mayor, 1963; John Metalski, mayor, 1963–1971; Frank J. Lada, the city's fifth and longest-running mayor, 1971–1985; Dominic Boccabella, mayor, 1985–1987; Gerald R. Richards, mayor, 1987–1995; Kenneth E. Ford, mayor, 1995–1999; and Levon G. King, mayor, 1999–2003. Former city administrator Richard A. Huebler was elected mayor in 2003 and still serves the city as of 2006.

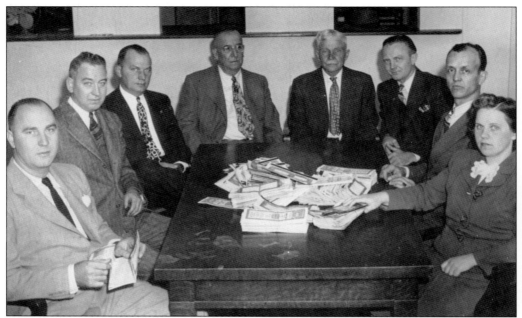

In 1944, this group of city officials gathers to work on the Ecorse municipal bonds. Present are, from left to right, John (Jack) Labadie, Alex Fitzgerald, Clarence L. Lichtenberg (mayor, 1959–1963), Frank Champagne Sr., Charles Schafer (father of George Schafer, village president 1953–1957), Henry V. "Cap" Herrick, Homer P. Howard, and Judge Lucille Siebert.

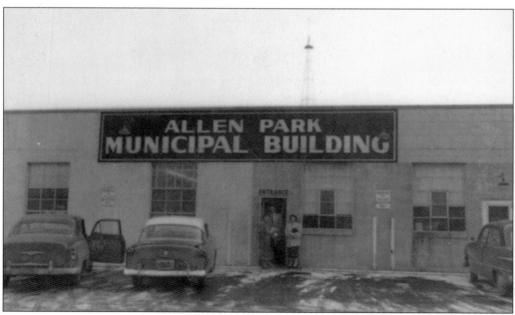

Standing in the doorway in 1954 of the Allen Park Municipal Building from left to right are Ethel Fairall, Don Pretty, and Mary Ellen Dunleavy. Even though the address was 6515 Roosevelt Street, the building faced Southfield Road. The tower in the background is the Chrysler air raid warning signal.

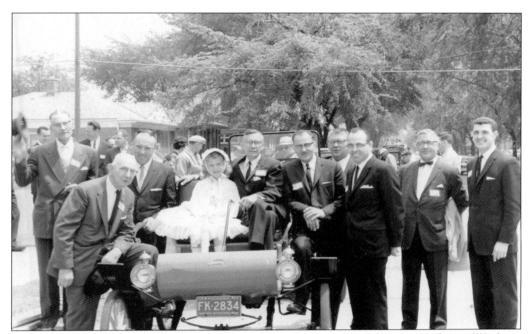

Allen Park always had parades. This is the Heritage Day parade celebrating Michigan Week on May 25, 1963. From left to right identified by last name are Weight, Reynolds, Cunningham, little Miss Hinds, Schwass, Paluch, Rodwell, O'Neil, Rodwell, and Pizzimenti

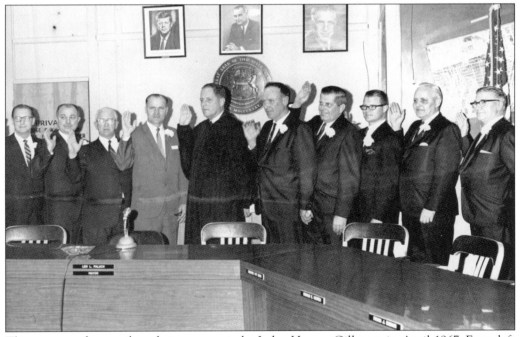

The mayor and council are being sworn in by Judge Horace Gillmore in April 1967. From left to right are Frank J. Lada, Anthony Foresi, Patrick Dunn, Leo J. Paluch, Judge Gillmore, Ralph Cunningham, Frank Bodnar, Ronald Weston, Judge Frank Burger Sr., and George Moore.

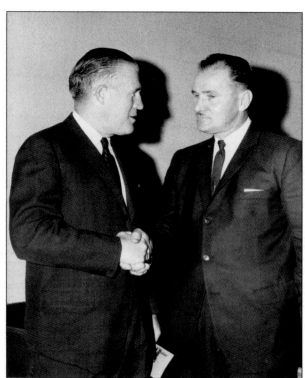

Many events in Allen Park drew officials on the state and national level to visit. Pictured is Michigan governor George Romney with Allen Park mayor Leo J. Paluch. It is not known what the occasion was at this time.

This building on Allen Road was one of the few buildings that housed the city business offices. Several buildings were used at various times in the history of Allen Park, including the old one-room schoolhouse on Allen Road. Pictured are Omar O'Neil and Mayor Morrison from Kalamazoo. It is May 1963 and Heritage Day during Michigan Week.

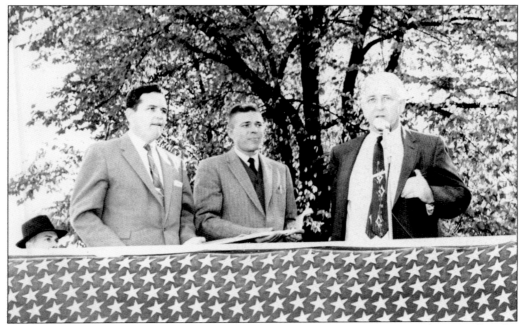

Mayor Osborne Pat Dunn is at the microphone in Champaign Park. It is not known what the nature of this occasion is. A young John (Jack) Rourke is on the left. The young man in the middle is unidentified. It may have been the arrival of engine No. 507 to Champaign Park.

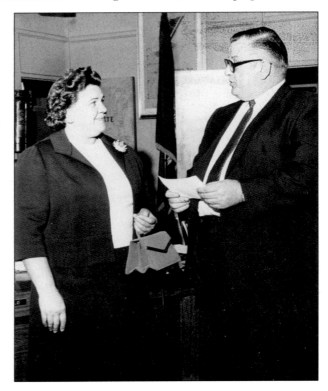

Mayor John Metalski is giving an award to an unidentified woman. The files of the Allen Park Historical Museum include many pictures such as this in which someone is being presented an award. The Polish influence in Allen Park is evident with two mayors of Polish descent. Metalski and Leo J. Paluch were both proud of their heritage.

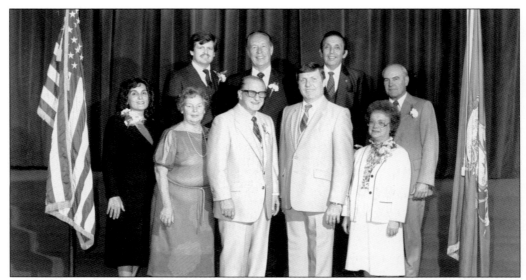

Mayor Frank J. Lada is pictured with his council. From left to right are (first row) Santa McNeal, council; Dorothy Moore, treasurer; Frank J. Lada, mayor; Gerald R. Richards, council; and Bernice Weiss; (second row) William O'Neil, council; Don Pretty, council; Dominic Boccabella, council; and Harold Duda, council. This administration produced two mayors, Boccabella and Richards, and Congressman O'Neil. Don Pretty was the postmaster in Allen Park, following in the footsteps of his father, Charles Pretty. One of Don's sons, R. Doug Pretty, became the superintendent of Allen Park public schools.

Mayor Frank J. Lada was one of the most popular mayors. He held office longer than any mayor to date, serving from 1971 to 1985. He got the title of the "kissing mayor" when he would politic by greeting the ladies with a kiss. This picture of, from left to right, Beverly Kelly, Vi Rinna, Lada, Marge Yesue, and Shirley Raupp was taken in the 1970s. Rinna served as secretary to Lada during his term. Kelly went on to be elected city clerk.

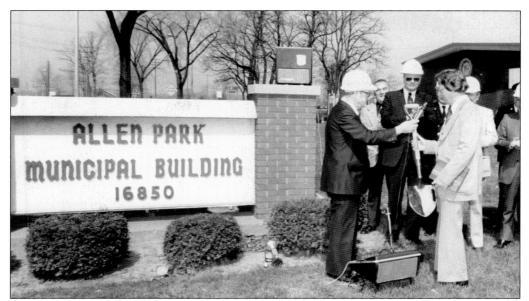

Soon after Frank J. Lada became mayor in 1971, the Gilead Baptist Church moved to Taylor, offering its building and seven and a half acres of land on Southfield Road for sale. This building and land were an opportunity to solve the city's needs for office space and other city facilities. Late in 1974, a wing of the building was ready to provide offices for the administrators. In 1975, the district court offices were in use. Plans to add a police department were being made.

This picture of the Allen Park Police Department was taken in 1959. Pictured from left to right are Roy Doughty, who became police chief; William Morris; Elmer J. Hall; George Bove; Kenneth E. Ford, who would go on to serve as mayor from 1995 to 1999; and Leo G. LeBlanc. This building that served as the police department was on White Street. A few other buildings served as police departments, including the one-room schoolhouse on the corner of Allen and Ecorse Roads. In the early days of Allen Park, police services were shared with Melvindale. As the city's population grew, the need for a police department was recognized.

This brand-new Edsel automobile that is being used as a police car was the pride of the police department in 1959. The Edsel, named after Henry Ford's only child, was designed at the Ford Design Center in Allen Park. The police vehicles in Allen Park have usually been models from the Ford Motor Company.

The ribbon-cutting ceremony of the newly dedicated Allen Park Police Department, located adjacent to the Allen Park Municipal Building, is seen here. There are many faces in the crowd, including, from left to right, unidentified; the first village police chief, Wilford Riley; Chief Roy Doughty; Mayor Frank J. Lada; G. Mennen Williams, who would go on to become the governor of Michigan; and Harold Duda. Other politicians are in the background.

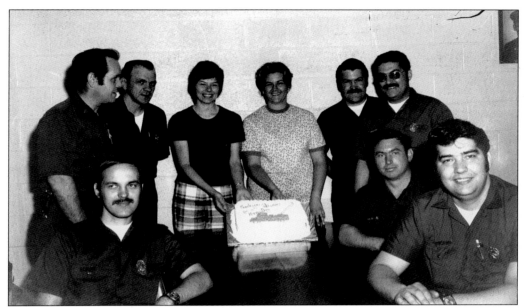

This group of firemen from the Allen Park Fire Department is being presented a cake that reads, "Thank you fireman, for a happy day." Some of the firemen who can be identified are Robert Jones, Richard Sinnott, and James Cabadas, who became chief of the department. The fire department was started at midnight on January 31, 1949, when the paid contract with the City of Lincoln Park for fire protection expired.

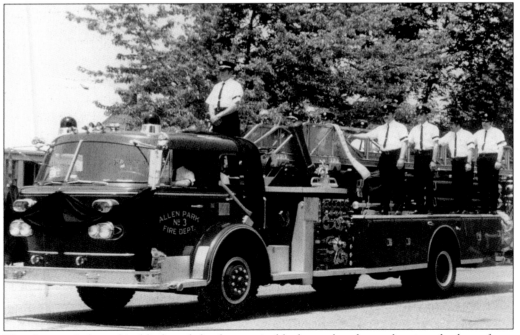

This fire truck draped in black and the firemen in black arm bands are showing the loss of one of their comrades who was in an automobile accident. The parade is most likely the Memorial Day parade that is held yearly by the VFW. The year is 1962.

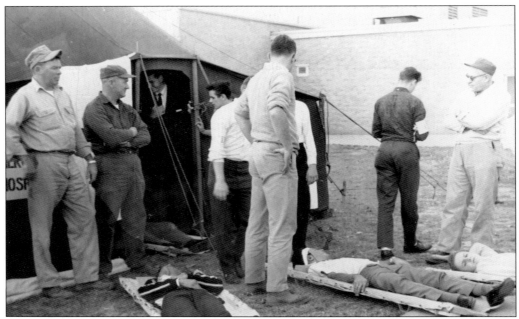

This picture of students from Allen Park High School was taken on October 28, 1964. They were participating in a mock disaster drill. The students set up a civil defense emergency hospital. The world unrest would affect many cities all over the United States. City officials, police, and firemen are assisting the students.

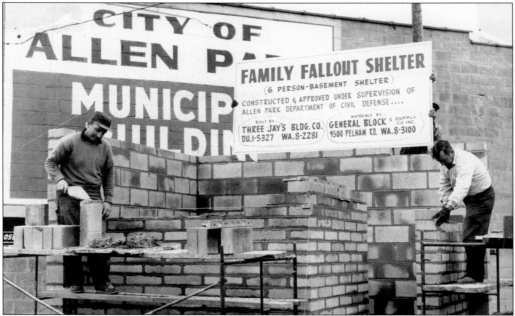

In November 1961, the Three Jay's Building Company and General Block and Supply built a family fallout shelter next to the Allen Park Municipal Building on Allen Road. The United States still had a fresh memory of World War II, and the cold war caused concern for all. The Allen Park Department of Civil Defense was formed to educate all citizens on this issue.

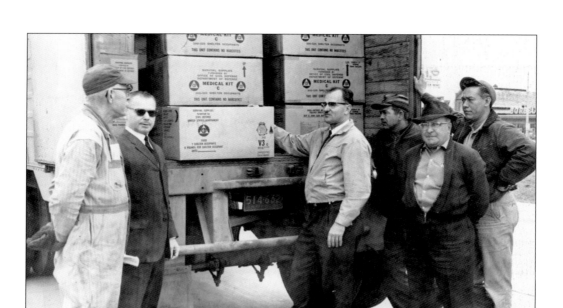

This group of men, ? Robinson, Mayor Leo J. Paluch, ? Himich, and ? Brant, is accepting the first delivery of shelter supplies in September 1964. Many public buildings, schools, and churches in the city had areas designated as shelters. This shipment was medical supplies and food. Across the street on the right is the Borbely Supermarket.

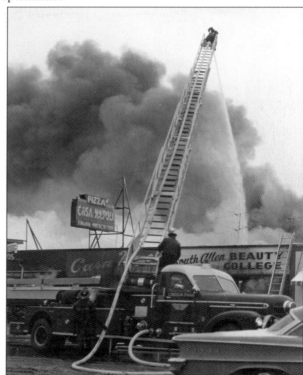

On March 17, 1959, the Lincoln Park Fire Department was called to a major fire in Allen Park. The cities that bordered one another in the early days in Ecorse Township worked together to provide protection for their towns. In the early days of Allen Park, the majority of fires were brush fires.

When police chief Wilford Riley retired from the Allen Park Police Department, he soon became the director of parks and recreation. Today men who played on teams that Riley coached remember the kind man who was everyone's friend. Riley would always offer to drive the youth in the community that he would see walking home in his Hudson automobile. He was one of the most honored and loved public officials in Allen Park.

The city always provided for both young and old. This skating rink ran along Southfield Road, close to where the ice arena is today. The land was wide open, and behind this area, faint images of stores and homes can be seen. This picture was taken in January 1959. Pioneer Elmer Theeck would often tell stories of the four or five farms that had ponds that the townspeople would use to skate on in the winter. They would also swim and fish in the ponds and creeks in the summer. Those days were already in the past in 1959.

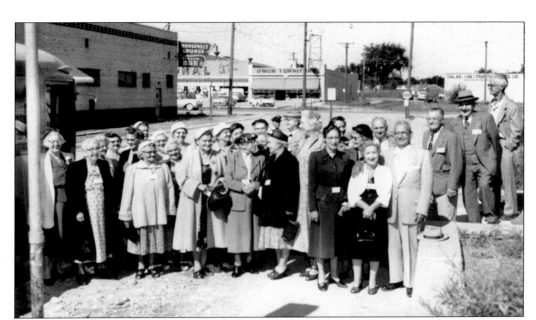

The members of the Golden Age Club are shown on September 5, 1957, ready to embark on a trip to the Michigan State Fair. Today the Parks and Recreation Department plans many events for the senior adults of Allen Park. Notice the dress they are wearing for the occasion. In the background at left are the National Food Store and the Union Furniture Store. On the right-hand side of the picture is Balas Steel, which is still in business today.

The need for an ice arena was a controversial issue in Allen Park. The ice arena was approved, and soon enough the Allen Park Hockey Association was playing teams from all over the state. This picture is the kickoff of the new arena with Ted Lindsey from the Detroit Red Wings hockey team throwing out the first puck.

The Allen Park Civic Arena not only hosted many hockey games and tournaments but is also used for various events in the city. When the ice is not down for hockey and skating, the arena is used for festivals, dog shows, garage sales, and many other events. In about 1977, the rock group Bachman-Turner Overdrive performed at this arena. This picture, taken in the 1970s, shows John Bockel (left), the owner of Park Athletic Supply, with Mayor Frank J. Lada.

This group of Allen Parkers is having a picnic at Champaign Park on Champaign and Pelham Streets. The park was named in honor of the Champagne family whose farm was on this land. Notice the name spelling is changed. Many times, pioneer family names take on a different spelling. In the early 1900s, many families enjoyed skating on the ponds on the property.

The John Riel Memorial Park was named in honor of the longtime parks and recreation director. This picture shows Mayor Lada giving Mrs. Riel a plaque on the occasion of the dedication. Pictured is a young Richard Huebler, the parks and recreation director who would be elected mayor of Allen Park in 2003.

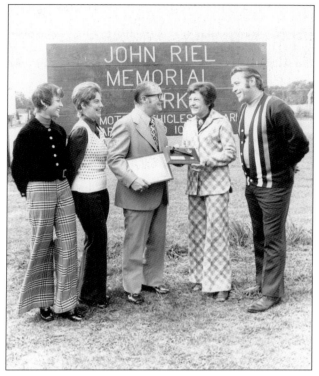

This picture was taken at the James R. Cunningham Memorial Park on December 15, 1965. In the picture at the dedication are Judy Blanton, commissioner; Mayor Leo L. Paluch; park director Lee Osborn, Christine and James Cunningham; and commissioner Edward Ochen. The park was named in honor of the Cunninghams' son. The Cunningham family owned the Camelot Inn on Southfield Road.

The Parks and Recreation Department always made sure the young people of the town had plenty to do. This wading pool was a place where young children would come for swimming lessons and to play on hot summer days. The pool is located in the back of the old North Junior High School on Allen Road. It is still used today.

The Department of Public Services is putting up a new sign at the corner of White and Roosevelt Streets. The relatively new fire department is in the background on Roosevelt Street. Notice the go-go boots the ladies are wearing.

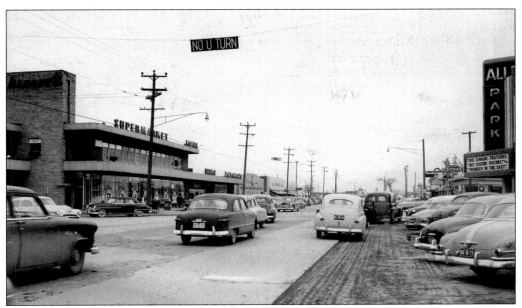

This street scene of Allen Park is one of the most favorite street scenes on file at the Allen Park Historical Museum. The street is being repaired. When this picture was taken in 1957, business was thriving. Many of the shoppers were from surrounding towns. Two favorite memories for Allen Parkers and visitors are Albert's Supermarket and the Allen Park Theater. Angle parking was popular at that time.

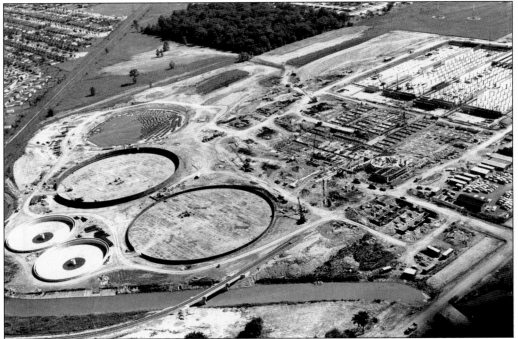

The Detroit Water Filtration Plant is pictured in January 1961. The plant stands in the place where many old farms once were. The land was a perfect spot of open land for such a spacious project.

This picture, taken in 1976, is at the Allen Park Municipal Building. From left to right, Orrin Wright, Mayor Frank J. Lada, and Frederick W. Schwass are pictured in the mayor's office. Wright, a historian, is the author of the bicentennial publication *Allen Park Heritage, 1776–1976*. Schwass was the first village president and also a historian. Much of the history that is known today is due to the research of both men. In 1976, there was much celebration in the city.

This picture of the Leiber family was taken on April 10, 1960, at the town hall. Pictured from left to right are young George Leiber, his brother Ken, Ken (senior), and Judy Lieber Hatch. The Allen Park Historical Museum is the benefactor of much history that was saved and passed to the new generations by the senior Ken Lieber. Many remember him at the local coffee shop telling tales of years gone by in the town.

Barrett Lafferty, city controller and photographer, pictured in the hat, has left a history of this town in pictures. The invaluable photographs are part of the Allen Park Historical Museum collections. His son Frank Lafferty was on the Allen Park Police Department and inherited his father's interest in Allen Park. One of Barrett Lafferty's grandsons, Jerry Lafferty is a teacher in Allen Park public schools. Jerry remembers going to his grandfather's house, where many times he would be allowed in the darkroom to watch him develop the many pictures he took of the city.

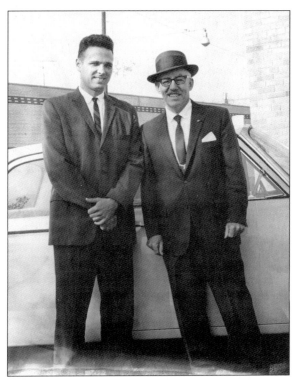

Judge Michael T. Russell, on the right, founded the Garden Work Program in 1983. This program allowed first-time offenders of District Court No. 24 to plant crops as a community service. The food grown by the offenders went to persons of limited means. This huge plot of land was behind the Allen Park Municipal Building and District Court.

In 1980, Judge Michael T. Russell held the first annual law day. Law enforcement units representing many departments gathered at the Allen Park Municipal Building. The cities of Allen Park and Melvindale worked together to bring law enforcement units from Wayne County and Canada. Fifth-, eighth-, and twelfth-grade students from schools in both cities are invited to come see the process of law. Chief judge John T. Courtright and district court judge Richard A. Page officially named this annual event the Michael T. Russell Law Day.

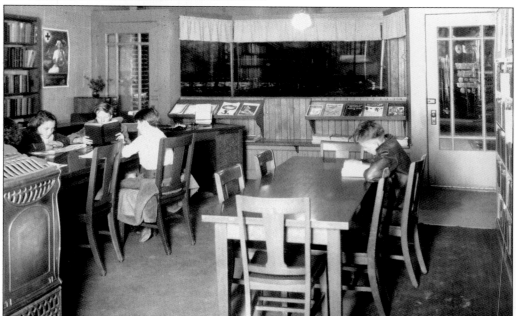

The Allen Park Public Library was established in 1927, agreeing with the Wayne County Library Board that the village would provide the quarters. The library was operated from three different locations. This library was on Allen Road and is now home to the Whipple Printing Company. The reflection in the glass windows shows a farmhouse and barn across the street.

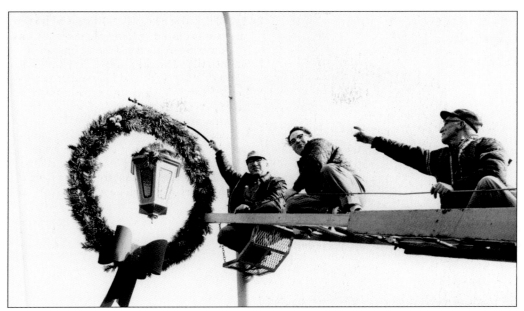

In the 1970s, the city bought new Christmas decorations. The Department of Public Services is putting up the decorations on Allen Road. Allen Park has always been a spirited town when it comes to the holidays. The Christmas decorations were from Frankenmuth. The Christmas parade was held on Saturday mornings beginning in the early 1950s. Budget cuts ended the parade for 12 years until it was brought back in 2002.

This is the dedication of the new police department in 1976. The police department looks on as the Boy Scouts and Girl Scouts present the colors. Eventually the police department was provided with the larger modern facilities it needed.

In January 1961, the Department of Public Services proudly displays vehicles for the newest service in town. The five new machines were bought to sweep the snow from the sidewalks. The growth of the town caused many of the service departments in the city to update the equipment. By this time, fire, police, and service equipment were being replaced.

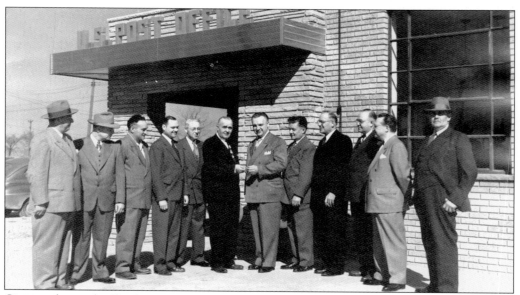

Civic and postal officials are present at the formal dedication of the new Allen Park Post Office branch at Park Avenue and Philomene Street. Pictured from left to right are Henry Lucy, Ray Hinzmann, John Dula, J. Turek, M. Thomson, J. Yagley, A. Karoley, C. Bowen, three unidentified men, and Louis Backus. This office was built by Ray Hinzmann and was dedicated as the Hinzmann Building. It is now the home of the Elks. The post office moved in the 1960s to its present site on Roosevelt Street.

Six

MEMORIES
EVENTS, SITES, AND CELEBRITIES

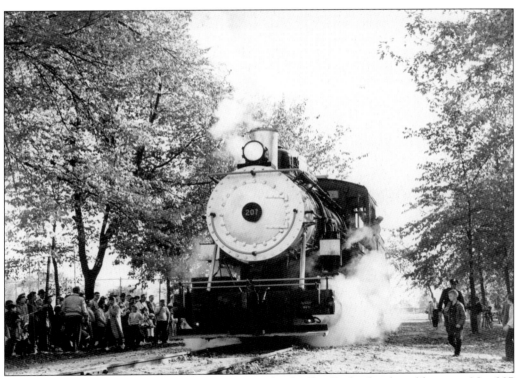

It was one of the most exciting days for the youth of Allen Park: the day old engine No. 207 came down the special track that was put down in Champaign Park just for that special train. The Detroit Edison Company was retiring old No. 207, and arrangements were made for the train to become part of the play equipment at the park. A lot of dignitaries were on hand to give speeches, the Allen Park High School band played, and many other exciting events took place on that day in 1961.

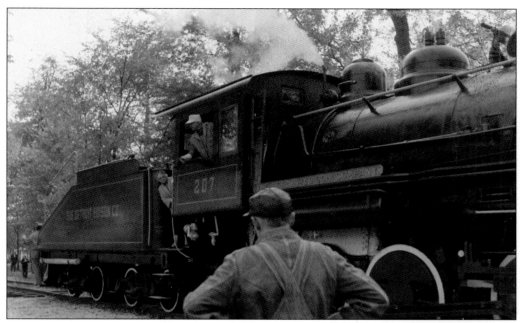

This engine was a favorite site in Allen Park. The engine got run-down when the floorboards rotted and it became dangerous to play in. The old train is one of the most remembered sites in town. The Allen Park Historical Museum still gets calls from men who remember the days when they were young boys playing at the park.

It is June 1961 and Linda Hicks has been crowned Miss Allen Park. In June 1946, the VFW started Allen Park Days with the outing being a day on Bob-Lo Island. In 1950, that event was replaced with a one-day carnival. In 1952, the event was moved from Champaign Park to the municipal parking area between Southfield Road and Philomene Street and became a five-day carnival. Other events were created to go along with the event. Games, races, fireworks, and the crowning of the Allen Park queen took place. Allen Park Days still exist, but the Miss Allen Park contest has ended.

The Allen Park Jaycee Bike Rodeo was held in the late 1940s and 1950s. The event is being held behind the Lapham School on Allen Road, which was renamed North Junior High School. The stretch of empty land in the background suggests that the city was still sparsely settled in this area.

It was an exciting day in Allen Park when the rodeo came to town. The Allen Park Jaycees sponsored and organized the event, which took place on Southfield Road in the municipal parking lot. Today many former members of the Jaycees recall shopping for a new pair of blue jeans that they all wore to the event.

In 1987, the sesquicentennial of Michigan, the first Allen Park Street Fair was held. The annual event is held the first Friday and Saturday in August. The event has grown to one of the largest craft fairs in southeast Michigan. This craft fair attracts people from all over the state of Michigan. (Courtesy of Dan Scott.)

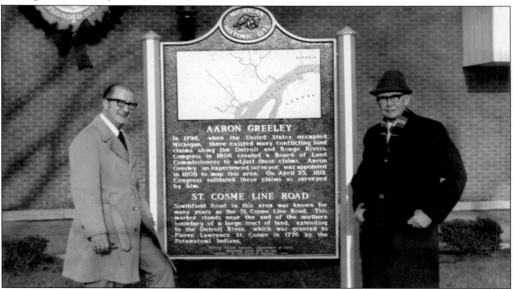

On Southfield Road in front of the Allen Park Municipal Building, a Michigan historic site marker designates two events in the city. In 1812, surveyor Aaron Greeley recorded with the United States government his surveying results that started across the road from this marker in Allen Park and extended to the Straits of Mackinac. The marker also designates that Pierre St. Cosme owned this land, which was given to him by the Potawatomi Indians, and the road was named in his honor.

The Christmas parade was held from the 1940s until 1990, when the parade was ended due to cost cuts in the city. The Allen Park Community Council formed a committee headed by Bruce Haberkern and Sharon Broglin to bring the parade back to the city. The parade was changed to a lighted night parade, and the city officials approved the return in 2002. Founded in 1953, the Allen Park Community Council is an organization of all the religious, fraternal, school, and organizational groups in the city that meets monthly. The idea is to create a coordinated calendar of events. It hosts one of the largest-attended dinners held in the city in the spring, at which each organization awards its own individual and a project. Other members, Marge Szalai, Barbara Curran, Don Eiden, Tillie Balogh, Ernie Holowinski, Joan Mechan, Dan and Rhea VandenBergh, and Vartkes and Pat Tadian, have worked endlessly to continue the group.

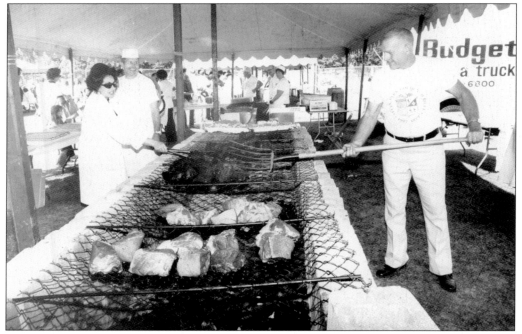

In 1977, the City of Allen Park celebrated 50 years of being incorporated. This is the ox roast that was held during Allen Park Days at Champaign Park. Thousands of residents came to the special event, which had festivities for all ages. This group is preparing the fire to cook the meat.

Allen Parkers were always fond of the business section on Allen Road, between Southfield Road and Roosevelt Street. This scene was captured after one of the biggest snowstorms in the history of southeast Michigan. In 1965, a record overnight snowfall paralyzed most of the southwest Detroit area, including Allen Park. Many schools and businesses were closed for two days. The shelves in the supermarkets were empty of staples as no deliveries could be made in many areas. The devastation cost millions of dollars.

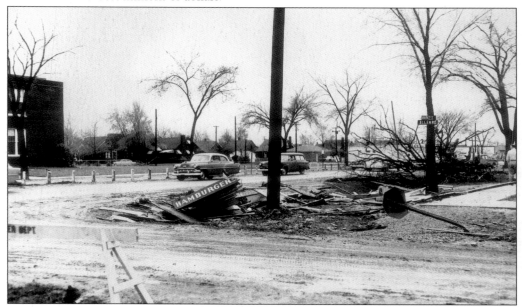

The tornado in the spring of 1957 was one of the most remembered events in Allen Park. This photograph was taken on the corner of Markese and Allen Roads. To this day, Allen Parkers tell the tale of the events of what was one of the major disasters in the town. There were no fatalities in Allen Park, but the tornado left devastating death and destruction in Flint. The hamburger sign tells the story of what happened across the street.

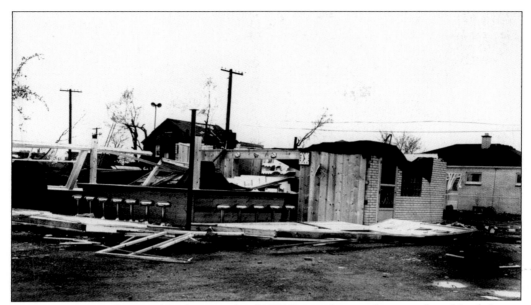

Gee's Drive-In was destroyed by the tornado of 1957. Located across the street from North Junior High School, this restaurant was frequented in force by the teenagers in town. Notice the old farmhouse still standing in the background at right.

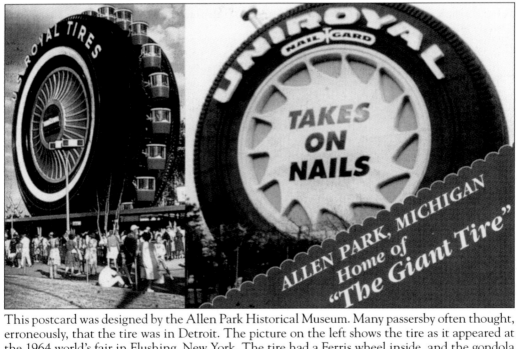

This postcard was designed by the Allen Park Historical Museum. Many passersby often thought, erroneously, that the tire was in Detroit. The picture on the left shows the tire as it appeared at the 1964 world's fair in Flushing, New York. The tire had a Ferris wheel inside, and the gondola cars were inside the treads. Over a million and a half visitors enjoyed the ride, including the widow Jacqueline Kennedy and her children, Caroline and John. The right side shows one of the five different tire designs that were used by U.S. Royal Tires, UniRoyal, and the current parent company Michelin.

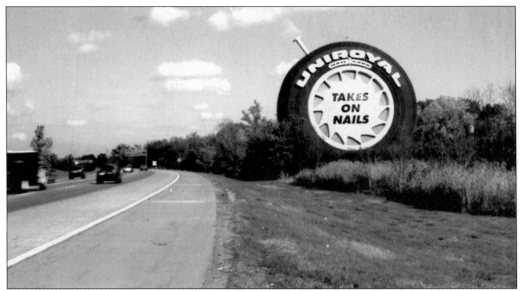

The giant tire, which stands along Interstate 94, was brought to Michigan by Kenneth Townsend of the Townsend Sign Company on 21 train car beds. The railroad is directly behind the tire. It has become an American icon and has been featured in many books, magazines, and articles. It has also been used in editorial comics relating to the Detroit area. Today the tire has a new style and the nail is gone. People take pictures of the landmark every day. (Courtesy of Vincent Martini.)

The railroad arches built by Henry Ford have become another icon. Ford built the arches in the 1920s to fulfill his dream of an electric railroad that would run from the Ford Motor Company Rouge plant in Dearborn to Toledo, Ohio. The arches have survived the many years of inclement weather.

The Detroit Lions' headquarters and training facility is located at 222 Republic Drive. The front of the building is in Allen Park, and the rest is actually in Dearborn. The Detroit Lions train at this facility, and all the publicity releases come from the offices at this location. Many times, visiting teams, local high schools, and other youth programs have used the facility. The Lions' headquarters was used for many activities relating to Super Bowl XL, held in Detroit in 2006.

Peter McWilliams was born on August 5, 1949. He attended Allen Park High School, graduating in 1967. Even as a young man he showed an interest in writing. He was 17 when he wrote his first book of poetry, *Come Love With Me & Be My Life*. This began a series of poetry books that have sold nearly four million copies. One of his biggest sellers is *How to Survive the Loss of a Love*, which has sold over two million copies. His books of poetry, personal growth, computer knowledge, and photography were on the *New York Times* best seller lists for months at a time. He has appeared on *The Oprah Winfrey Show*, *Larry King Live*, *The Phil Donahue Show*, and other programs.

Tom DeAngelis graduated from Allen Park High School in the 1960s. His dream of a career in radio would become a reality. A friend of the family, Fran Williams, suggested that he use the name Johnny Williams. Taking her advice, he used the name that would be known through the airwaves as "the voice of Detroit." His career has taken him to the most played radio stations since the 1950s. Williams was a disc jockey for WKNR, CKLW, WNIC, and is currently heard on WMGC. He also had a syndicated program that was broadcast in the Midwest. Tom DeAngelis wrote the words to the hit song "Wait a Minute" by Tim Tam and the Turn Ons, a group of friends from Allen Park High School.

"Hitsville USA," the home of Motown in Detroit, was the inspiration of many young musicians who dreamed of being on stage one day. Allen Park teenager Rick Weisand liked the sounds of Marvin Gaye, and Smokey Robinson of the Temptations. He formed the group Tim Tam and the Turn Ons, consisting of friends from Allen Park High School. Don Grundman, Nick Butsicaris, John Ogen, Earl Rennie, and Rick's brother Danny Weisand together recorded "Wait a Minute," "Cheryl Ann," and "Kimberly." "Wait a Minute," written by DeAngelis, went on to become a top 10 hit.

Anne Carlini was born on February 20, 1960. Her parents were Emil and Nancy Carlini. She attended the Bennie Elementary School and North Junior High School and graduated from Allen Park High School in 1978. Carlini graduated from the Specs Howard School of Broadcasting. Her early jobs were at WKKI in Celina, Ohio, WXEZ 105 in Toledo, Ohio, WWCK 105 in Flint, and WLLZ and WNIC in Detroit. In November 1987, Carlini was hired at WRIF, where she is still on the air today. Her voice is heard in national radio and television commercials.

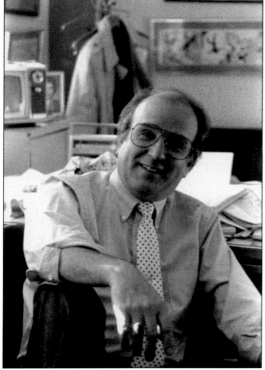

Larry Wright was born in Youngstown, Ohio, in 1940. His family moved to Detroit when he was two years old. At the age of 13, the family moved to Allen Park. Wright attended Allen Park public schools, including Allen Park High School. In high school, he was well known for his cartoons and comic strips. His work often appeared in the school newspaper. Wright first worked as a cartoonist for the *Detroit Free Press* from 1965 to 1976. Since 1976, he has worked for the *Detroit News* as a political cartoonist. He created *Motley the Cat* and *Wright Angles*. His syndicated cartoon feature *Kit 'n' Carlyle* is a regular feature in the *Detroit News* comics section.

Emil Carlini graduated in 1942 from Lincoln Park High School. He started his professional career the following year. Emil played professional baseball for 10 years and semiprofessional for 3 years. He played for various teams, including the Philadelphia Phillies. After retiring from baseball, he moved to Allen Park and went to work for the Ford Motor Company. Emil and his wife, Nancy, had three children, Anne, James, and Gino.

Tom Tresh and his family lived in a home that was used as a model for one of the first electric homes in Allen Park. Tom, the son of former major-league catcher Mike Tresh, attended Allen Park High School. The school yearbooks show him involved in various sports, including baseball. After graduation in 1954, he attended Central Michigan University. Tom was 23 years old when he broke into the big league on September 3, 1961, with the New York Yankees. A damaged knee in 1967 hastened the end of his career.

Seven

HONORED
THE VETERANS ADMINISTRATION
MEDICAL CENTER

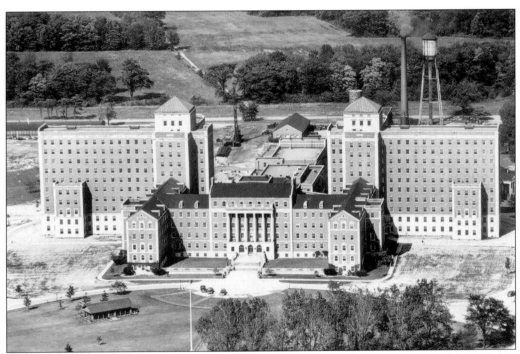

This view of the Veterans Administration medical center was taken in 1949. The hospital that was dedicated in 1939 was now caring for veterans of World War II. The influx of men and women from this war would require additions to be built to the hospital. This complex was declared to be one of the best medical facilities in the world for men and women of the armed forces. The medical complex had buildings on the property for physicians, nurses, and administrators. Many service organizations donated time at the hospital.

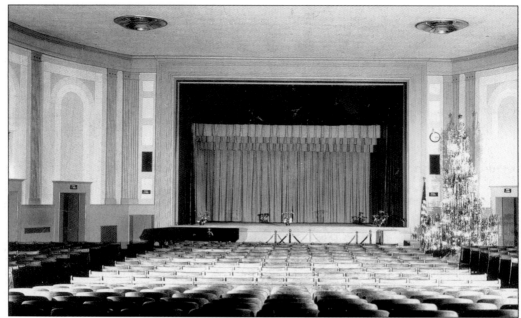

This picture shows the auditorium of the veterans' hospital. The Christmas tree on the right indicates that it is Christmastime. Many events were held to brighten the days and sometimes months that the patients would have to stay. There were carnivals, cultural events, entertainers, bingo games, picnics, family days, and many other occasions to add joy to the veterans' lives.

This picture was taken at the annual Memorial Day parade. Members of Vietnam Veterans United of Allen Park are marching down Champaign Street. Gary Steffens carries the prisoner of war flag. Steffens was drafted into the army in 1970. After returning home from Vietnam, he married and moved to Allen Park. Steffens is dedicated to the fullest possible accounting of prisoners of war and those missing in action and participates in parades throughout the Downriver area. David Babbage, Michael Cameron, Arthur Worley, Gary Dell, Frank Emerick, Ken Lieber Jr., Michael Riordan, and Lloyd Teller were in the service during the Vietnam War.

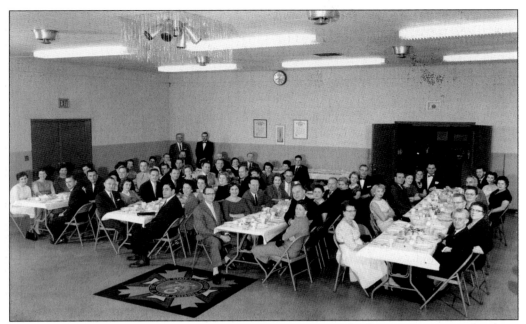

This picture is of an occasion at the VFW hall on Ecorse Road. This organization is for those who served the country on a foreign shore. The American Legion is for those who served the country during a conflict. The hall on Ecorse Road has unusual architecture. The small hall near the corner is the top of a boat. The building was added to the boat in 1950.

Don Eiden, a member of the VFW, is presenting police chief Roy Doughty with a new flag on the occasion of the opening of the new location of the Allen Park Police Department. For years, Eiden has served the city in many ways. The loyalty of the members of the military organizations to causes relating to the city and the men and women in the armed forces is endless. A list of some of those who served during World Ward II includes Charles Amore, Sal Scarpace, Maurice Watters, Robert Doss, Steward Vining, William Cozad, James Kenzie, Fred Seabloom, Charles Bray, Joe Schlaff, Dave Nelson, George Milne, Ray Grabowski, Joe Bellante, Otto Schornstein, Louis Gaty IV, Bruce Bryant, and Don Eiden. Those in other conflicts are Cory Zuchette, Tom Egan, Elton Theeck, Gordon Kochevar, and Eric Waidelich.

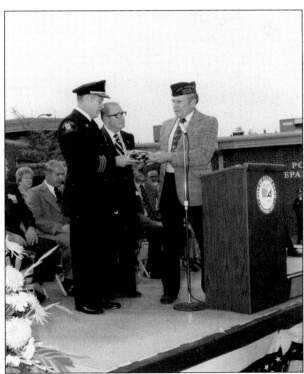

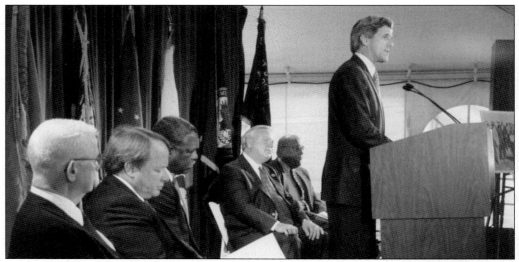

It was a cool, gray October day in 2002 when officials gathered to formally close the Veterans Administration medical center. The veterans who came for the ceremony were somber. A page in medical and military history was about to close. The huge flag on the old pole was brought down for the last time as military men of years past methodically folded the stars and stripes. The ceremony continued in the large tent that had been assembled for the crowd. Pictured from left to right are Allen Park mayor Levon King; Edsel Ford, the grandson of Henry Ford; two unidentified veterans' officials; and Congressman John Dingell. Sen. John Kerry is making comments for the last ceremony at this hospital.

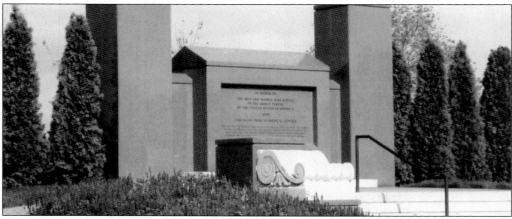

The inscription on this monument at the corner of Outer Drive and Southfield Roads reads, "In Honor of the men and women who served in the armed forces of the United States of America and the Allen Park VA Medical Center." It was decided at meetings with representatives from the VFW, Washington, D.C.; the National Historic Preservation, Washington, D.C.; the Michigan Historic Preservation; the Ford Motor Land Development Corporation; and the Allen Park Historical Museum that a monument would be built to remember the presence of the hospital. The monument would have the cement trim from the hospital incorporated into the monument. The Allen Park Historical Museum arranged to save the much-loved urns from the front entrance, the bench and altar cloths from the chapel, the brass chandeliers from the front inside entrance, and a few other items. The urns were used as decor in a new park on White and Allen Roads, which exists today. The rest of the items are at the museum. (Courtesy of Vincent Martini.)

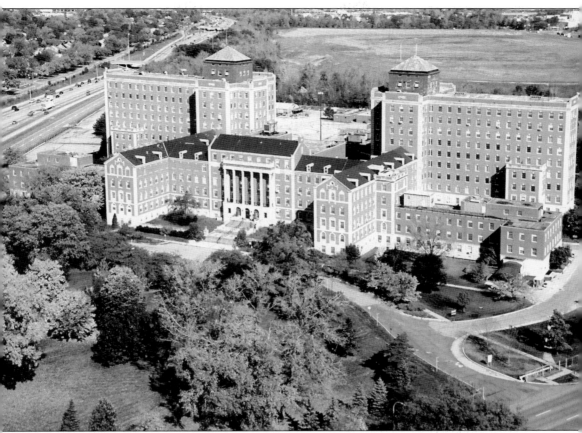

On July 8, 1937, at 2:00 in the afternoon, Henry and Clara Ford signed papers that would change Allen Park for years to come. The quitclaim deed gave 39 acres of land on which a hospital would be built to serve the men and women of the armed forces of the United States of America. A clause in the deed read, "The lands conveyed are to be used solely by the United States of America for the purpose of construction and maintaining a Veterans Administration facility and when no longer used for this purpose it shall reverse to its grantors or heirs." After many years of caring for the men and women who served this country, the worn-out facilities were closed. In 1996, the patients were transferred to the John D. Dingell Veterans Administration Medical Center in Detroit. Today the monument to the national historic site stands on the corner along with a beautiful shopping center where the veterans' hospital once stood.

ACROSS AMERICA, PEOPLE ARE DISCOVERING SOMETHING WONDERFUL. *THEIR HERITAGE.*

Arcadia Publishing is the leading local history publisher in the United States. With more than 3,000 titles in print and hundreds of new titles released every year, Arcadia has extensive specialized experience chronicling the history of communities and celebrating America's hidden stories, bringing to life the people, places, and events from the past. To discover the history of other communities across the nation, please visit:

www.arcadiapublishing.com

Customized search tools allow you to find regional history books about the town where you grew up, the cities where your friends and family live, the town where your parents met, or even that retirement spot you've been dreaming about.